A DRAWING IN THE SAND

A STORY OF AFRICAN AMERICAN ART

WRITTEN AND ILLUSTRATED
BY JERRY BUTLER

Zino Press
CHILDREN'S BOOKS

Portrait of John Murphy, Sea Captain by Joshua Johnston, *Old Arrow Maker and His Daughter* by Edmonia Lewis, *Tree Landscape* by Edward Bannister, *Gamin* by Augusta Savage, and *Café* by William H. Johnson are reprinted with permission of the National Museum of American Art, Washington, D.C./Art Resource, New York. *Parade* © by Jacob Lawrence, is reprinted with the permission of the Hirshorn Museum and Sculpture Garden/Smithsonian Institution, Washington, D.C. *Singing Head* © by Elizabeth Catlett/ licensed by VAGA, New York/Art Resource, New York. *Sunday after the Sermon* © by Romare Bearden Foundation/licensed by VAGA, New York/Art Resource, New York. *Annunciation* by Henry Ossawa Tanner is reprinted with permission of the Philadelphia Museum of Art, Pennsylvania. *Harmonizing* by Horace Pippin is reprinted with permission of Allen Memorial Art Museum, Oberlin College, Ohio. *Building More Stately Mansions* by Aaron Douglas is reprinted with permission of the Art Galleries and Collections of Fisk University, Nashville, Tennessee. *Spiritcatcher* © by Betye Saar and *Delta Doo* © by Alison Saar are reprinted with permission of Jan Baum Gallery, Los Angeles, California, and the artists. *Injustice Case* © by David Hammons is reprinted with permission of the Los Angeles County Museum of Art, California. Photographs of Henry O. Tanner and Aaron Douglas are reprinted with permission of the Art Galleries and Collections of Fisk University, Nashville, Tennessee. Photo of Augusta Savage is reprinted with permission of the Schomburg Center for Research in Black Culture, New York.

Written, illustrated and designed by Jerry Butler. Edited by Dave Schreiner. Art direction by Patrick Ready and Maggie Zoeller. Educational consultant: April Hoffman. Author's consultant: Frieda High (Wasikhongo Tesfagiorgis)

Library of Congress Cataloging-in-Publication Data

Butler, Jerry, 1947 -
 A drawing in the sand : a story of African American art / written and illustrated by Jerry Butler
 p. cm.
 Includes bibliographical references.
 Summary: Describes Jerry Butler's development as an artist and his discovery of the long and beautiful tradition of Afro-American art that preceded him.
 ISBN 1-55933-216-6
 1. Butler, Jerry, 1947 - .—Juvenile literature. 2. Afro-American artists—Biography—Juvenile literature. 3. Afro-American art—Juvenile literature. [1. Butler, Jerry, 1947 - . 2. Artists. 3. Afro-Americans—Biography. 4. Afro-American art.] I. Title.
 N6537.B89A2 1998
 704.03'96073—dc21 98-4139
 CIP
 AC

10 9 8 7 6 5 4 3 2 1

DEDICATION

FOR MY FAMILY

MY FATHER
EUGENE BUTLER,
MY MOTHER
KATHERINE CRYER BUTLER,
MY GRANDMOTHER
ARTISE BUTLER,
MY BROTHERS AND SISTERS,
CARRIE JEAN TURNER,
ROBERT EARL BUTLER,
EVERETT CHARLES (ROY) BUTLER,
LARRY DARNELL BUTLER,
CHRISTOPHER BUTLER,
ARTIS MARIE SMITH,
MARY ELIZABETH KIRKENDOLL,
RONNIE GAIL BUTLER
AND

MY HOMEROOM TEACHER,

MS. PONJOLA POSEY ANDREWS
AND

THE PEOPLE OF THE
PLEASANT SPRINGS CHURCH
COMMUNITY

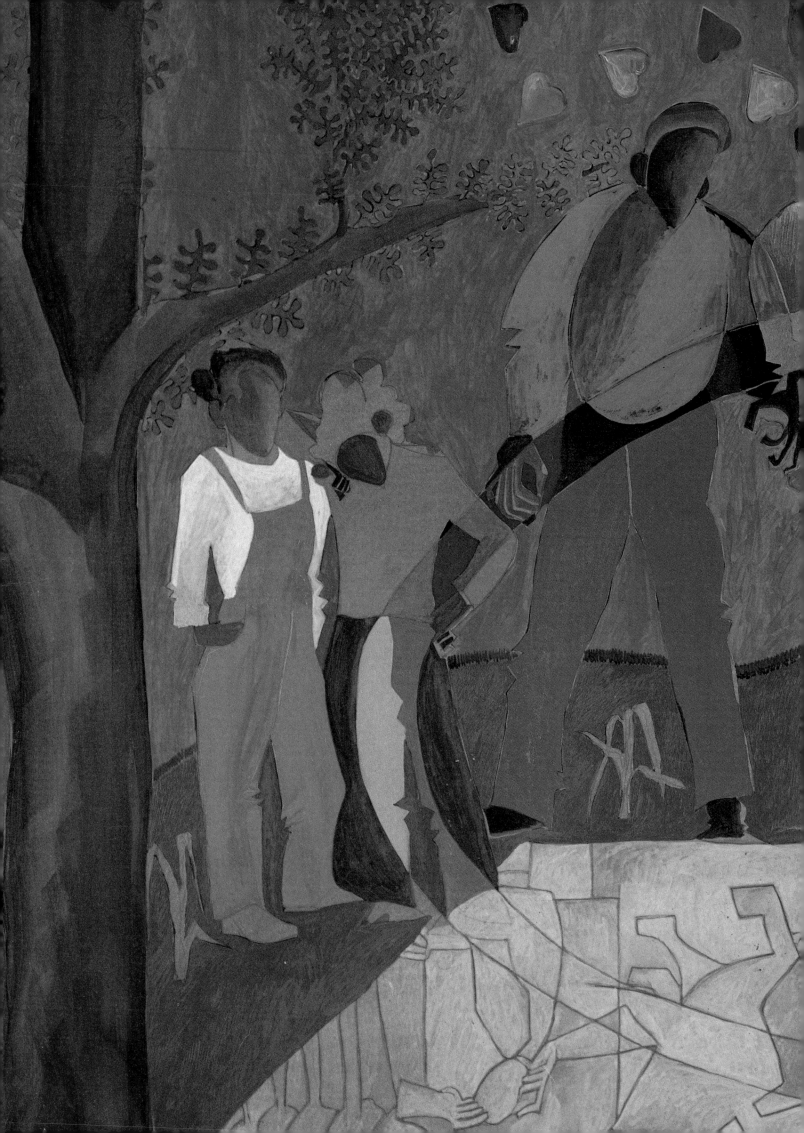

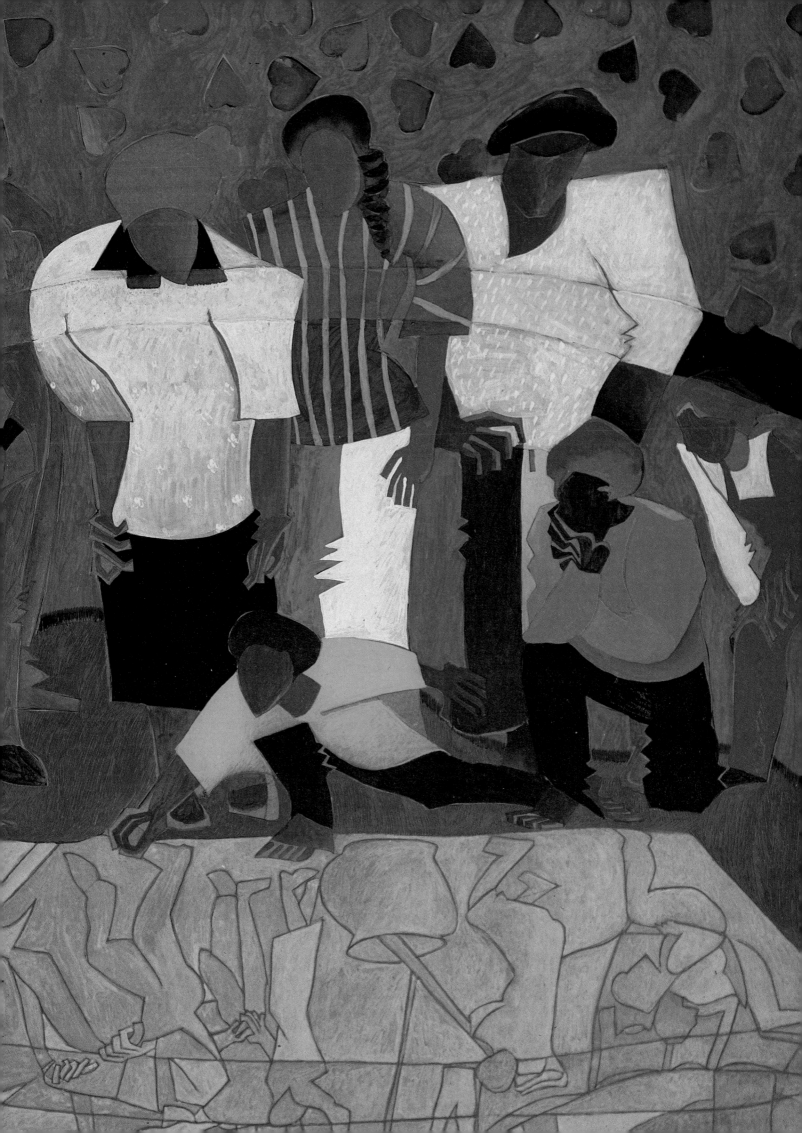

CHAPTER

1

IT ALL BEGAN A LONG TIME AGO, WHEN I WAS FIVE YEARS OLD. I WAS PLAYING IN MY YARD OUTSIDE MY HOME IN MAGNOLIA, MISSISSIPPI. MAGNOLIA IS IN THE DEEP SOUTH — ABOUT SIX MILES FROM MCCOMB AND ABOUT FIVE MILES NORTH OF THE LOUISIANA BORDER. WE HAD TWENTY ACRES OF FARMLAND THAT STRETCHED FROM THE ROAD TO JUST BEYOND A LINE OF THICK WOODS IN BACK OF THE HOUSE, RIGHT NEXT TO DR. BROOKS'S BIG FARM. THE ANIMALS IN THE WOODS KEPT US FED IN WINTER; THE FARM KEPT US FED IN SUMMER. IT WAS THE TIME OF YEAR JUST AFTER WINTER, WHEN YOU COULD FEEL THE COOL DIRT BENEATH YOUR FEET DURING THE PLOWING AND WE COULD PROP OPEN THE WINDOWS TO LET THE WARM BREEZES IN AGAIN. SHIRTS AND PANTS PINNED ON THE LINE OUTSIDE DANCED LIKE FLAT PEOPLE TO THE MOTION OF THE WIND. THE SUN WAS SHINING AND FRESH GREEN LEAVES MOVED WITH THE RHYTHM OF THE CLOTHES ON THE LINE. THE GROUND WAS WARM ENOUGH FOR ALL THE KIDS TO LEAVE THEIR SHOES INSIDE AND RUN AROUND BAREFOOT. TO CELEBRATE THIS NEW WARMTH, WE WERE HAVING A FAMILY GATHERING. THERE WERE ELEVEN OF US IN MY FAMILY ALONE, AND THERE WERE MAYBE TWENTY OTHER RELATIVES WHO LIVED NEARBY. THESE WEREN'T ALL BLOOD RELATIVES — THEY WERE FAMILY BECAUSE MAYBE THERE WAS NO ONE ELSE FOR THEM TO BE FAMILY WITH. MY AUNT LILLY LIVED ACROSS THE ROAD FROM US AND I SAW HER EVERY DAY, BUT I

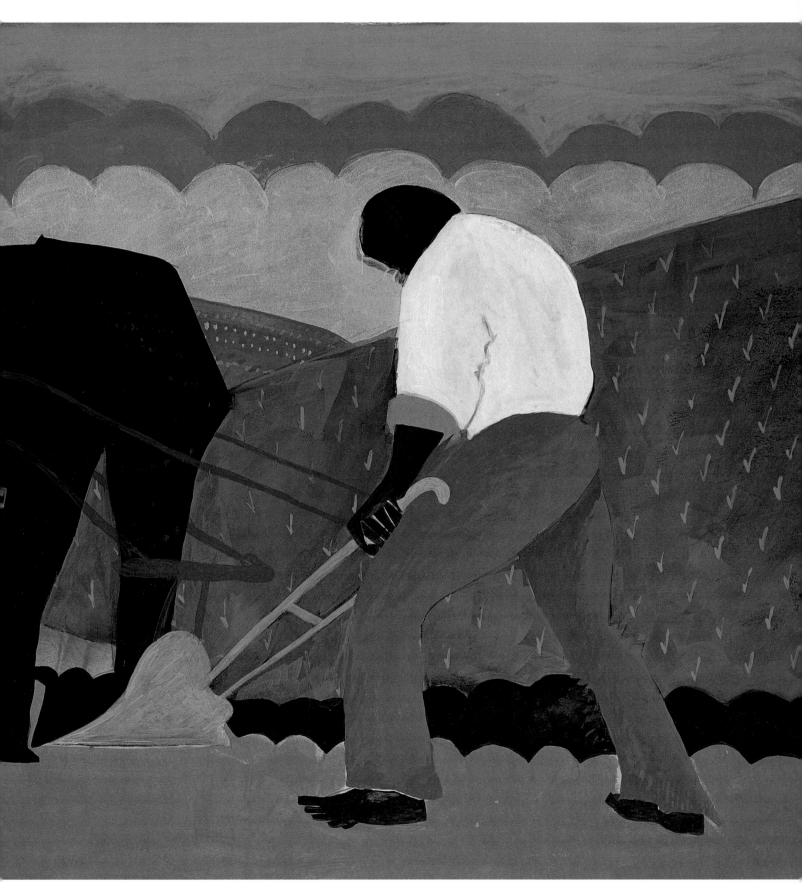

COULD NEVER GET AN ANSWER AS TO HOW EXACTLY SHE WAS MY AUNT. WE ALL RESPECTED AUNT LILLY, AND IT SEEMED TO ME

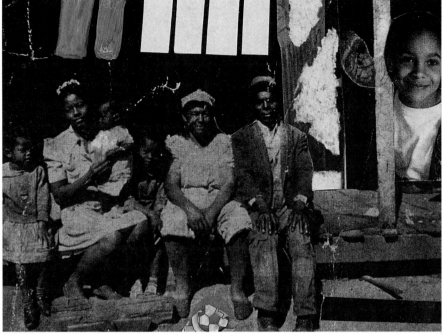

MY DAUGHTER VANESSA, FAR RIGHT, AND MAMMA, GRAND MAMMA BIRTHA, GRANDPA DUDLY AND KIDS

SHE KNEW A LOT OF THINGS — ALTHOUGH NOW THAT I THINK OF IT, I HARDLY EVER HEARD HER SPEAK AT ALL.

I WAS DRAWING IN THE RED, SANDY DIRT BETWEEN THE PECAN AND OAK TREES IN OUR YARD. I DREW THERE ALL THE TIME, WALKING AROUND THE CLEARING, SCRATCHING THINGS IN WITH A POINTED STICK. I USUALLY DREW PICTURES OF COWBOYS OR SOLDIERS, BUT THIS TIME I WAS DRAWING ALL THE PEOPLE AT OUR HOUSE. I SHOWED MY FATHER PLOWING AND MY MOTHER COOKING. MY SISTERS AND BROTHERS, AUNTS AND

UNCLES WERE ALL IN THERE DOING SOMETHING. I WANTED TO DRAW EVERYBODY BECAUSE THEY WERE ALIVE IN MY HEAD, DOING STUFF AND TELLING ME TO BEHAVE.

GRAND MO LU WAS IN THE PICTURE, TOO. SHE WAS MY GRANDMOTHER ON MY FATHER'S SIDE. I DON'T KNOW WHY, BUT I COULD DRAW HER AND GRAND MAMMA BIRTHA REALLY WELL. MAYBE IT WAS BECAUSE THEY TAUGHT ME DIFFERENT THINGS, DIFFERENT WAYS OF DEALING WITH THE WORLD. GRAND MO LU'S REAL NAME WAS ARTISE, ALTHOUGH US KIDS NEVER CALLED HER THAT. SHE SEEMED FRAGILE COMPARED TO EVERYBODY ELSE, BUT THERE WAS NO DOUBT IN ANYBODY'S MIND THAT SHE WAS THE

HEAD OF THE FAMILY. THERE WAS ONLY ONE WAY GRAND MO LU EVER CAME OVER TO OUR HOUSE, AND THAT WAS UP THE ROAD THAT BROUGHT HER RIGHT PAST MY DRAWING SPOT. SHE WALKED VERY SLOWLY; SHE ALWAYS WALKED SLOWLY — OFTEN STANDING TO TAKE IN THE VIEW, LIKE A PAINTER THINKING ABOUT MAKING A PICTURE. I NEVER SAW HER MAKE ANY MOVES THAT WERE IN ANY WAY HURRIED. LIKE ALWAYS, SHE TURNED IN UNDER THE TREES. THIS TIME, THOUGH, SHE CAME OVER TO WHERE I WAS DRAWING. GRAND MO LU LIKED ME A LOT, PROBABLY BECAUSE I WAS QUIET AND OFTEN WALKED THE HALF MILE TO HER HOUSE TO VISIT HER. THAT DAY SHE JUST STOOD THERE WATCHING ME WITHOUT SAYING ANYTHING.

THEN SHE CALLED FOR EVERYBODY TO COME OVER. SOMETHING IN HER VOICE MADE PEOPLE STOP WHAT THEY WERE DOING AND OBEY HER. WHEN EVERYBODY GOT WITHIN A GOOD RANGE SHE SAID, "LOOK AT THIS, LOOK AT WHAT THIS BOY IS DOING." SO EVERYBODY SETTLED AROUND THE DRAWING,

LINING UP AROUND ITS EDGES. IT SEEMED AS IF THEY LIKED LOOKING AT THEMSELVES IN ANOTHER WAY, OR MAYBE IT MADE THEM FEEL IMPORTANT OR SET APART FROM THE REST OF THE WORLD FOR A BRIEF MOMENT IN TIME. NOBODY SAID ANYTHING. THEY JUST LOOKED AT THE DRAWING AND WAITED FOR MY GRANDMOTHER TO SAY SOMETHING. GRAND MO LU BEGAN TO TALK, BUT IT WAS ALMOST TO HERSELF, NOT MEANT FOR ANYONE ELSE TO HEAR. "THIS IS SPECIAL," SHE SAID. "BLACK FOLKS HAVE BEEN DOING THINGS LIKE THIS FOR YEARS — MAYBE EVEN CEN- TURIES. IT'S JUST THAT WE DON'T TALK ABOUT IT SO MUCH." THIS WAS THE FIRST TIME PEOPLE HAD EVER REALLY LOOKED AT MY DRAW- INGS. USUALLY THEY WOULD JUST RUN OVER THEM, ESPECIALLY THE OTHER KIDS. NOBODY RAN OVER THAT DRAW- ING. IT STAYED THERE IN THE SAND UNTIL THE RAIN WASHED IT AWAY.

CLOCKWISE FROM TOP LEFT, MY DAUGHTER RACHELLE, GRAND MAMMA BIRTHA, AUNT PIGNINNY, AND AUNT LINNIE V

9

CHAPTER

2

THE SMOKEHOUSE

The first time I thought of being an artist was when Grand Mo Lu started calling me one. People would ask all us kids — there were nine of us — what we wanted to be when we grew up. Whenever I said I wanted to be an FBI agent or something, Grand Mo Lu would say, "You're already an artist. That's enough to be." So I began to think of myself that way.

Grand Mo Lu talked to me about art and life when she showed me the many things she collected in an old smokehouse in back of her home. The smokehouse was taller than her house and seemed almost as big. It was built to cure meat, but by the time I was old enough to visit her, it was filled with her maps, books, fine homemade quilts, beautiful plates and vases, and other things that made it hers. There was never a set time to go there. If I got my work done, I'd go visit her. Nobody else but me was allowed to go in there, and I made sure I didn't overspend my welcome or misuse anything. There was

10

Joshua Johnston lived in Baltimore, Maryland, a little bit after the Revolutionary War. He started his life as a slave but bought his freedom and set up shop as a portrait artist. Rich people around Baltimore paid him money to paint their pictures. Because he lived in Maryland and sometimes traveled south, he had to carry his freedom papers — papers that showed he wasn't a slave — wherever he went. Otherwise he would have been locked up or even killed as a runaway slave. Because he was able to paint

PORTRAIT OF JOHN MURPHY, SEA CAPTAIN
BY JOSHUA JOHNSTON

11

EDMON
LEW

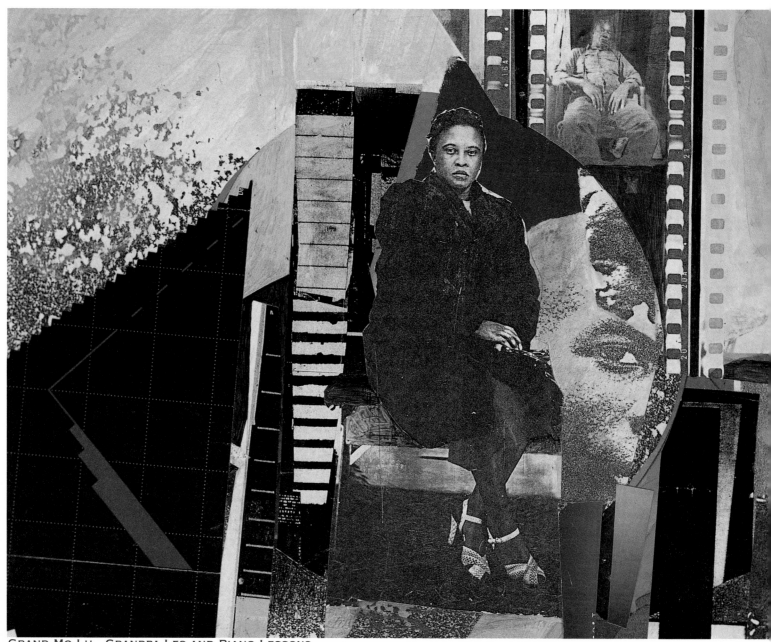

GRAND MO LU , GRANDPA LES AND PIANO LESSONS

IA
IS

OLD ARROW MAKER AND HIS DAUGHTER
BY EDMONIA LEWIS

ALWAYS A PLACE PREPARED FOR ME TO DRAW AND THAT MADE ME FEEL AS IF I REALLY DID HAVE SOME SPECIAL TALENT.

OF ALL THE THINGS GRAND MO LU COLLECTED, SHE LOVED HER MAPS OF AFRICA THE MOST. I WOULD ALWAYS ASK TO SEE THOSE MAPS. THEY SEEMED TO HAVE EVERY DETAIL YOU COULD NEED OR DESIRE; THERE WAS A LOT OF WRITING ALL OVER THEM. WE WOULD LOOK AT THEM AND SLIP INTO FARAWAY PLACES. GRAND MO LU WOULD TALK JUST ENOUGH TO LET ME KNOW WHERE SHE WAS GOING IN HER MIND. "YOU SEE THIS PLACE HERE? THAT'S WHERE YOUR GREAT-GREAT

good likenesses of people, he got a lot of work. Johnston would often work on his canvases before calling on his subjects. He might finish the costume and the pose of a person before he even got to somebody's house. Then he had the person copy the pose that was already on the canvas and finished the head. That way, he could work on the details of what the people wore on his own time and save time when he was painting the actual portrait.

Edmonia Lewis was born around 1843 in the state of New York. She started her life with the name Wildfire. She was the daughter of a black father and a Chippewa Indian mother. Both her parents died when she was just a little girl, and she was raised by the Chippewa tribe. Her brother had made some

13

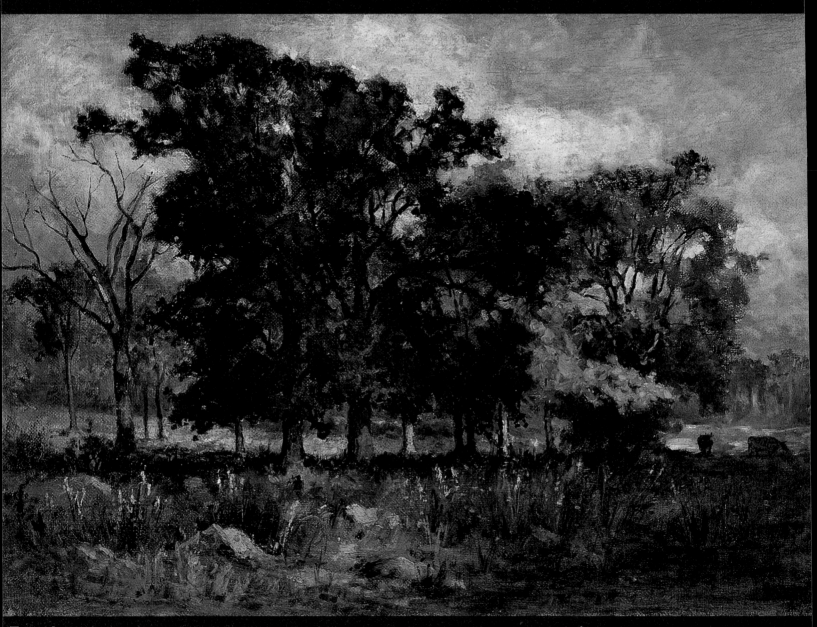

Tree Landscape by Edward Bannister

14

EDWARD BANNISTER

money in the California gold rush of 1849, and he gave her money to get an education. She went to Oberlin College in Ohio, where she changed her name to Mary Edmonia Lewis. She also ran into trouble there. Two girls said she tried to poison them, and a white mob beat and almost killed her. The charges were thrown out of court, and Lewis fled to Boston. That was where she studied sculpture and began to make a lot of money from her work. One of her pieces was of a white Civil War colonel who died leading an all-black military unit. The money she earned allowed her to travel to Europe, where she felt freer than in the United States. For most of the rest of her life, she lived in Italy.

Edward Bannister

never went to Europe. Instead, he used his anger at a newspaper article to become a great artist. Bannister was born in Canada in 1828 but lived in Boston, Massachusetts. In 1867, a New York newspaper ran an article saying black people were unable to produce art. That made Bannister furious. He had been a barber who painted in his spare time; but after he read the article, he devoted his full time to painting beautiful land-scapes. In 1876, one of his paintings won a big prize at the Philadelphia Centennial Exposition. The judges were shocked when they found out Bannister was black, and

GRANDDADDY IS [...]
THE PEOPLE THE[...]
JUST LIKE HIM.[...]

MY ANCESTORS — THE PEOPLE WHO CAME BEFORE ME IN MY FAMILY — CAME TO THE UNITED STATES AS SLAVES STOLEN FROM AFRICA. MAYBE THAT'S ONE REASON I DIDN'T THINK MUCH ABOUT IT WHEN GRAND MO LU TALKED ABOUT THE GREAT AFRICAN AMERICAN ARTISTS OF THE PAST. TO ME AT THAT TIME, ANY BLACK PERSON DOING ANYTHING DIDN'T REALLY COUNT. WE WERE THE POOR RELATIONS IN AMERICA. IT WAS LIKE THE DIFFERENCE BETWEEN PLAYING BASEBALL IN A FARM FIELD OR PLAYING ON A FIELD WITH PATTERNED GRASS CUTS, WHITE LINES, REAL BASES, A BATTER'S BOX, A PITCHER'S MOUND, AND A WIRE SCREEN BEHIND THE CATCHER. BLACKS WERE PLAYING OUT IN A PASTURE SOMEWHERE AND WEREN'T REALLY IN THE BIG LEAGUES. TODAY, I'D PICK THE PASTURE OVER THE BALLPARK. A BALLPARK SEEMS BARREN COMPARED TO THE FIELDS WHERE THE PLAYERS COULD BARELY SEE THE BATTER BUT COULD JUMP TO FULL

ᴇᴅ at the crack of ᴛʜᴇ bat and leap over rocks and bumps to catch a long fly ball under a tree right next to the road. You had to play better if you were playing in the pasture.

It took me a long time to figure out that the pasture had many advantages over the big league diamonds. And it took me an even longer time to realize that there were black artists actually in the big leagues.

So at that time and in that place, I wasn't interested in being like any of the black artists Grand Mo Lu told me about. I wanted to be the first real black artist ever. By that I mean I didn't just want to be an artist for black people but a black artist for all people. I wanted to draw things that would help people think of themselves in a different way. I knew nothing about the artists who had come before me — artists like Robert S. Duncanson, Edward Bannister, Edmonia

Lewis, Joshua Johnston — artists who had played on the fancy field.

Grand Mo Lu and I talked about everything in the smokehouse. She liked to talk about what it takes to be successful. "Always smile," she said, "but never enough to show your gums. Nobody likes to see gums. And don't grin. Look right at people when you got something to say. Be clear. Make sure you listen to people when they're talking to you. If you're going to get anyplace in this world, you must know some things that will help you. Lord knows, there's enough stuff out there to hold you back. Don't add to it with a bad attitude." I never looked upon things like this as learning. It was just something we talked about. Sometimes when I came out of the smokehouse, I'd be kind of buzzing a little bit with all the possibilities of places I could go and things I could do.

16

◆ ◆ ◆

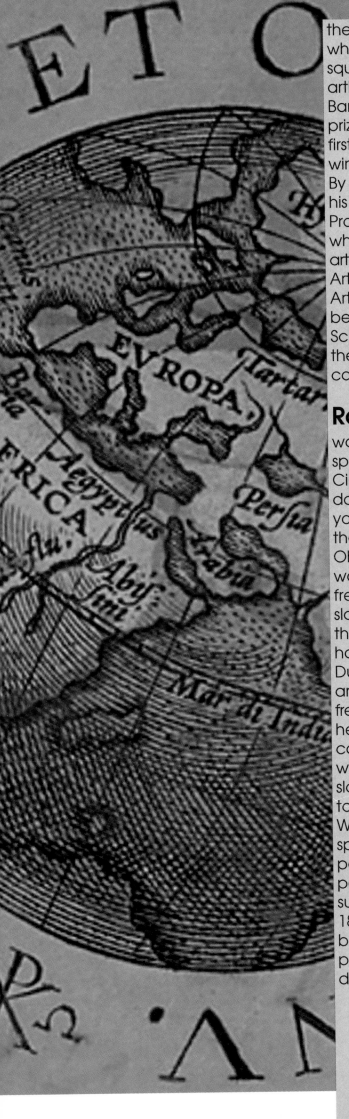

they almost didn't give him what he had won fair and square. But some other artists in the contest said Bannister should get the prize, and he became the first African American to win a national art award. By this time, Bannister and his family had moved to Providence, Rhode Island, where he and two other artists started the Providence Art Club. The Providence Art Club eventually became the Rhode Island School of Design, one of the best art schools in the country today.

Robert Duncanson

was born in 1821 and spent much of his life in Cincinnati, Ohio. This was a dangerous place for a young black man before the Civil War because the Ohio River in Cincinnati was the border between freedom in Ohio and slavery in Kentucky and the South. Even though he had never been a slave, Duncanson was another artist who had to carry his freedom papers everywhere he went. Some people called abolitionists — they wanted to abolish, or end, slavery — gave him money to study art in Europe. When he came back, he spent most of his time painting landscapes. These paintings made him very successful. From 1850 to 1860, he was probably the best African American painter in this country. He died in 1872.

17

CHAPTER 3

BECAUSE I WAS TALL FOR MY AGE, I STARTED FIRST GRADE A YEAR EARLY. EVEN THEN, I WAS NEARLY A HEAD TALLER THAN THE OTHER KIDS IN MY CLASS. AT THAT TIME, EVERY PUBLIC PLACE IN THE SOUTH WAS SEGREGATED. THAT MEANS BLACKS AND WHITES HAD TO STAY APART IN PLACES LIKE RESTAURANTS, BUSES, AND PARKS. THE SCHOOLS WERE NO DIFFERENT — WHITE KIDS WENT TO THEIR SCHOOLS, AND BLACK KIDS WENT TO THEIRS. MY GRADE SCHOOL HAD TWO ROOMS, WHICH WASN'T UNUSUAL FOR A BLACK SCHOOL IN A SMALL TOWN. THE KIDS IN GRADES ONE THROUGH FOUR WERE CRAMMED IN ONE ROOM, AND EVERYBODY IN GRADES FIVE THROUGH EIGHT WAS PACKED IN THE OTHER. BECAUSE THERE WASN'T ANY MONEY FOR SUPPLIES, THE TEACHERS HAD TO COME UP WITH THEIR OWN MATERIALS FOR CLASS. ONE DAY A TEACHER GAVE ME A SMALL PICTURE OF A HUMAN EYE. SHE ASKED ME TO COPY IT BIG AND SHOW ALL THE PARTS SO EVERYBODY COULD SEE IT WHEN SHE HUNG IT UP. I WORKED ON THAT DRAWING FOR A LONG TIME, AND THE TEACHER USED IT.

SOON MY DRAWINGS HUNG IN BOTH ROOMS AT SCHOOL. I SOMETIMES

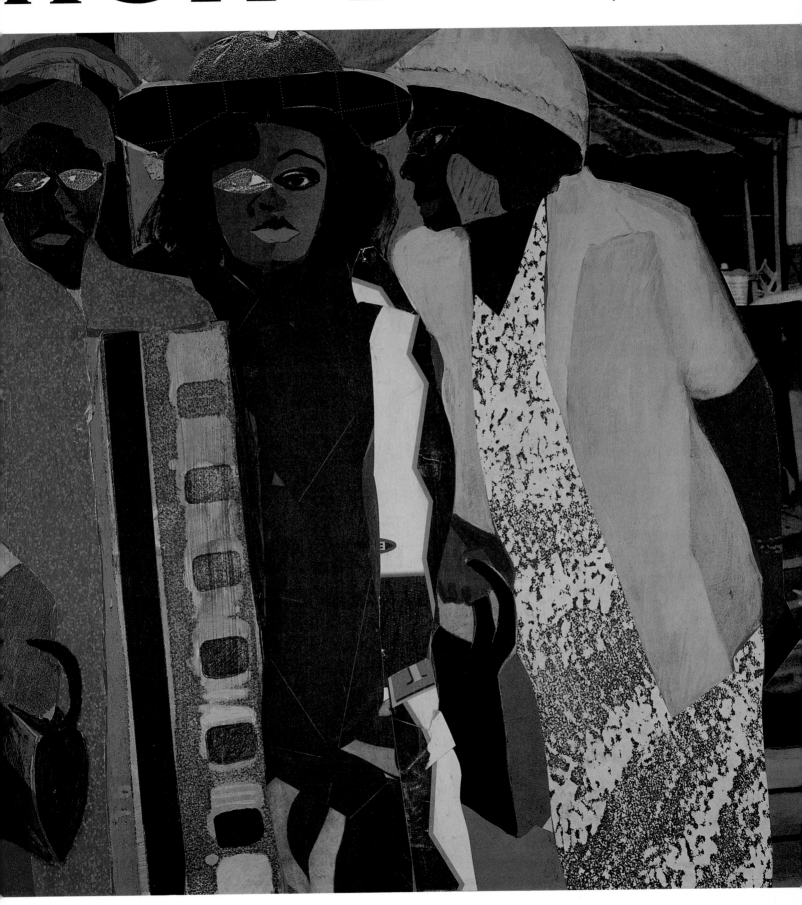

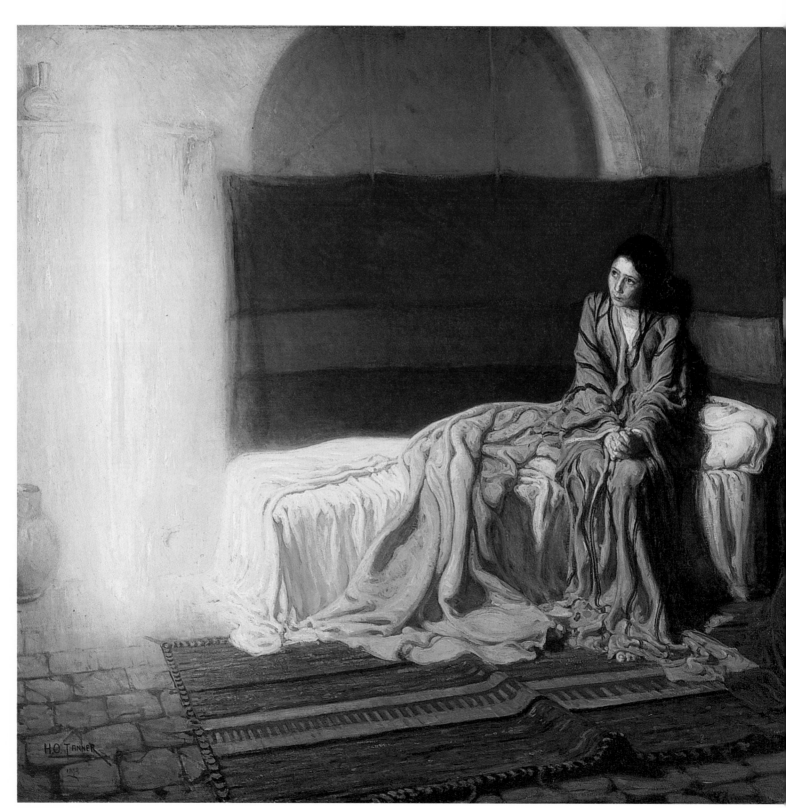

ANNUNCIATION BY HENRY O. TANNER

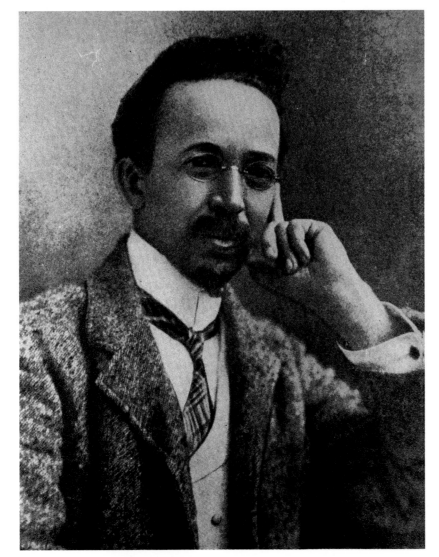

HENRY O. TANNER

HENRY O. TANNER

Henry O. Tanner

was born in 1859 in Pittsburgh, Pennsylvania. Like Edmonia Lewis, Tanner lived most of his life in Europe. He didn't want to live in the United States because he hated the prejudice against black people and he had a white wife — an American he met in Europe. This marriage could have gotten Tanner killed in the United States in the 1890s. Henry's father was a minister, and Tanner spent a great part of his life painting scenes from the Bible. In 1891, he visited France and made that his home for the rest of his life. In 1895, he painted *Daniel in the Lion's Den*, a story

SPENT A GOOD PART OF THE DAY DOING DRAWINGS FOR THE CLASSROOMS. I LOVED IT. FOR THE FIRST TIME, SOMEBODY BESIDES GRAND MO LU ENCOURAGED ME IN MY ART. OTHER PEOPLE BEGAN POINTING OUT SOME THINGS IN MY PICTURES THAT WEREN'T SO GOOD. ANY ARTIST NEEDS ENCOURAGEMENT AND HONEST CRITICISM IN ORDER TO GET BETTER, AND THIS ALL HELPED ME OUT. I WANTED TO TRY DIFFERENT THINGS, SO I BEGAN DRAWING PORTRAITS OF PEOPLE. ABOUT HALF THE TIME, THE PEOPLE I DREW THOUGHT THE PICTURE SORT OF LOOKED LIKE THEM. I FIGURED THAT WAS PRETTY GOOD.

WHEN I WAS A BIT OLDER, GRAND MO LU GOT ME A JOB DRAWING THE SUNDAY SCHOOL LESSON FOR OUR FAMILY'S CHURCH, THE PLEASANT SPRINGS BAPTIST CHURCH. SHE ASKED ME TO DRAW A PICTURE OF JESUS KNOCKING ON A DOOR AND ASKING PERMISSION TO COME IN. THE POINT OF THE DRAWING WAS THAT JESUS KNOCKS ON EVERYONE'S DOOR, BUT IT'S UP TO THE PERSON INSIDE TO LET HIM IN AND BE SAVED. THIS

21

WAS AN EASY PICTURE FOR ME TO DO BECAUSE GRAND MO LU HAD ALREADY TOLD ME ABOUT HENRY O. TANNER. GRAND MO LU KNEW QUITE A BIT ABOUT HENRY TANNER. ONE TIME SHE SEEMED TO FREEZE AS I WAS DRAWING IN THE SMOKEHOUSE. SHE JUST STARED AT THE DRAWING. WHEN I ASKED HER WHAT THE MATTER WAS, SHE SAID, "OH, NOTHING. NOTHING FOR YOU TO BE BOTHERED ABOUT. BUT IF YOU KEEP UP THAT DRAWING STUFF, YOU'RE GOING TO BE JUST LIKE THAT TANNER FELLOW." GRAND MO LU PROBABLY LIKED HIM BECAUSE HE DID MANY RELIGIOUS PAINTINGS, AND MY GRANDMOTHER WAS A SPIRITUAL WOMAN. TANNER'S PAINTINGS INSPIRED ME. I KNEW WHAT JESUS LOOKED LIKE AND WHAT CLOTHES HE WORE BECAUSE OF TANNER. BUT MY JESUS WAS BLACK AND TANNER'S JESUS WAS WHITE.

GRAND MO LU PRESENTED MY DRAWING OF JESUS KNOCKING AT THE DOOR AT THE REVIEW, WHICH CAME RIGHT AFTER SUNDAY SCHOOL

AND RIGHT BEFORE THE SERVICES. EVERYBODY LIKED THE DRAWING AND SO I GOT THE JOB OF ILLUSTRATING THE LESSON FOR THE REVIEW EVERY WEEK. THAT MEANT I COULD DRAW RATHER THAN SIT THROUGH SUNDAY SCHOOL. THE HARDEST PART ABOUT THOSE DRAWINGS WAS READING AND KNOWING THE LESSON WELL ENOUGH TO GET THE POINT OF IT ALL. IF I DREW SOMETHING THAT DIDN'T HAVE MUCH TO DO WITH THE LESSON, THERE MIGHT BE TROUBLE.

THOSE SUNDAY SCHOOL DRAWINGS LED TO MY FIRST PAYING ART JOBS. WHEN I WAS ABOUT FOURTEEN, GRAND MO LU CONVINCED OUR PASTOR AT THE PLEASANT SPRINGS CHURCH TO LET ME DO A MURAL ON THE BACK OF THE BAPTISMAL POOL. A MURAL IS ARTWORK PAINTED ON A WALL. THE BAPTIST CHURCHES WHERE I GREW UP HAD THESE POOLS BEHIND THE PULPITS. BAPTISTS BELIEVE THAT TO BE TRULY ONE WITH THE LORD, YOU HAVE TO BE BAPTIZED TOTALLY UNDER WATER. YOU WALK DOWN THESE LITTLE STEPS IN THE POOL, AND THE

PREACHER DUCKS YOUR HEAD UNDER WATER AND BRINGS YOU BACK UP AGAIN. IT'S CALLED "TOTAL IMMERSION." MY MURAL HAD SCENES PAINTED ON THE POOL'S BACK WALL, ABOVE AND BELOW THE WATER LINE. IT SHOWED JOHN THE BAPTIST BAPTIZING JESUS. ABOVE THE WATER LINE, YOU COULD SEE THEM TOGETHER, AND BELOW THE LINE, IT LOOKED LIKE THEY WERE STANDING IN THE WATER. AFTER I FINISHED IT, THE PEOPLE IN THE CHURCH TOOK UP A COLLECTION TO PAY ME. THEY COLLECTED WHAT SEEMED TO ME AT THE TIME AN UNBELIEVABLE AMOUNT OF MONEY, SOMETHING LIKE $140.

AS IT HAPPENED, WE HAD A BIG REVIVAL MEETING SHORTLY AFTER I FINISHED THE MURAL. THE PURPOSE OF A REVIVAL MEETING IS TO REFRESH OR REBUILD YOUR FAITH. IT CAN ALSO HELP CONVERT PEOPLE FROM OUTSIDE THE RELIGION. THESE MEETINGS WERE ALWAYS BIG EVENTS. OUR REVIVALS STARTED AT CHURCH ON SUNDAY AND WENT ON ALL DAY. WE'D GO HOME TO EAT AND THEN CAME BACK AGAIN AT NIGHT FOR MORE OF THE REVIVAL.

from the Bible, and it won a prize in Paris. He was the first African American to win an international prize for his painting. He kept on working until he died in 1937. When he started out, Tanner painted many fine scenes showing black people. Pictures like *The Banjo Lesson*, which shows an old man teaching a young boy an instrument, made him famous in this country. Tanner was one of the most famous painters in the United States during his lifetime. Many black leaders wanted him to come back to America to inspire young black artists. But Tanner said he didn't want to fight the prejudice against blacks in the United States. Then they wanted him to show in his art how black people lived. He refused. He said he agreed with what these black leaders were trying to do, but he didn't see himself as a black artist. He said he was "simply a man and artist living and working in a free society." He wanted to be an artist who took on all sorts of subjects, not just one.

THIS WENT ON EVERY NIGHT OF THE WEEK UNTIL IT WOUND UP THE NEXT SUNDAY. PEOPLE CAME FROM ALL OVER THAT PART OF MISSISSIPPI FOR OUR REVIVALS. EVERYBODY SAW THE MURAL WHEN THE PASTOR THREW BACK THE CURTAINS IN FRONT OF THE POOL. WHEN THE VISITORS SAW THE ART, THEY ALL WANTED ONE FOR THEIR CHURCH, TOO. THE CHURCH NEAREST OUR OWN WANTED ANOTHER PICTURE OF JESUS KNOCKING AT THE DOOR, AND THE MEMBERS TOOK UP THEIR OWN COLLECTION TO PAY ME. THAT HAPPENED SEVEN TIMES IN THE NEXT TWO YEARS, AND THE MONEY GOT BIGGER AND BIGGER. THE BIGGEST COLLECTION REACHED $390 OR $400.

A COUPLE OF THOSE MURALS STILL EXIST. I'D LIKE TO GET THEM IF I COULD — I'D DESTROY THEM IN A SECOND. MANY ARTISTS FEEL THEIR EARLY WORK ISN'T MUCH GOOD. I FEEL THE SAME WAY ABOUT THOSE MURALS, ALTHOUGH THEY HELPED ME LEARN AND DECIDE WHAT I WANTED TO BE.

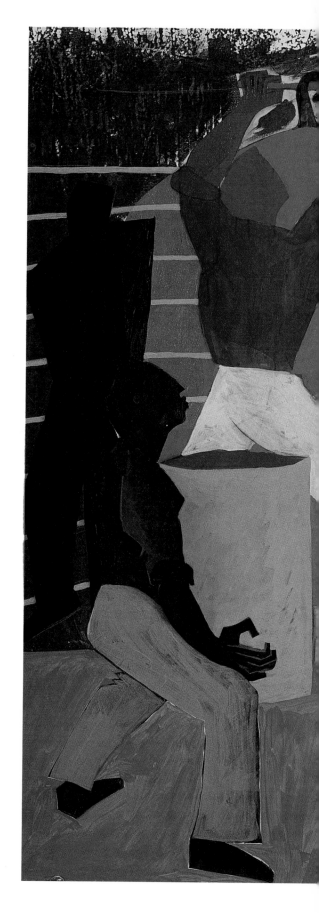

CHAPTER

4

ON THE FARM

Grand Mo Lu continued to help me find my path in art. When she visited her relatives in Chicago, she would bring back posters and pamphlets about art. And she was the first to tell me about the artists of the New Negro Movement, better known today as the Harlem Renaissance.

But along with art, I also liked farming,

25

BUILDING MORE STATELY MANSIONS BY AARON DOUGLAS

AARON DOUGLAS

The Harlem Renaissance was a time in the 1920s when African American art of all kinds got popular. Most important, black artists used their art to show how black people lived. Some black leaders like W.E.B. Du Bois and Alain Locke had been pushing for this right along. They said it was time for black people in America to celebrate who they were. They believed the black viewpoint was second to none and blacks should be proud, not ashamed, of themselves. In other words, blacks should stop thinking they were in the pasture and start thinking they belonged in the real WHICH WAS SOMETHING I KNEW BY HEART. BY THAT I MEAN I KNEW WHEN TO PLANT BY THE FEEL OF THE AIR AND DIRT, AND HOW TO CARE FOR SICK ANIMALS BY INSTINCT, AND HOW TO PLAN WHERE CROPS WOULD BE PLANTED. WHEN I WAS ABOUT NINE YEARS OLD I TOOK OVER MOST OF THE CHORES ON OUR FARM. MY FATHER WORKED IN A BOX FACTORY DURING THE WEEK, AND ON WEEKENDS HE CUT HAIR FOR ALL THE BLACK PEOPLE IN THE AREA.

AARON DOUGLAS

HE DIDN'T HAVE MUCH TIME FOR PLOWING AND CROP TENDING, SO THAT ALL BECAME MY JOB. FARMING IS HARD WORK, BUT I ENJOYED BEING OUTSIDE AND NOT FIGHTING AROUND WITH MY PARENTS ABOUT CHORES. WE RAISED CATTLE AND SMALL CROPS SUCH AS PEAS, POTATOES, CORN, SUGAR CANE, PEANUTS, AND THE LIKE.

ART HAD TO WAIT UNTIL DARK OR WHEN THE FARMING WAS FINISHED. THE FUNNY THING IS, I KEPT THINKING ABOUT ART ALL THE TIME. I'D SPEND HOURS OUT IN THE FIELDS FOLLOWING TWO MULES AND LOOKING AT THE SKY, DREAMING UP PAINTINGS, PICKING OUT FORMS IN THE CLOUDS AS THEY MOVED INTO AND OUT OF IMAGES IN MY MIND. I'D LOOK AT THE TREE LINE ON THE WOODS AND FIND SHAPES TO FIT INTO A PAINTING. I'D ALSO WRITE STORIES IN MY MIND, WITH ME AS THE HERO AND ALL WITH GOOD ENDINGS. IN THESE STORIES, I'D GO TO THE BIG CITY AND BECOME A PAINTER AND MAKE PIC-TURES OF THE SUFFER-ING AND JOY I EXPERI-ENCED EVERY DAY. I'D DO MIND PAINTINGS OF

GRAND MO LU OR GRANDPA LES OR MAYBE GRAND MAMMA BIRTHA AND DISPLAY THEM SO PEOPLE COULD LOOK AT THESE BEAUTIFUL FOLKS. ART WAS ALL AROUND ME AND LIFE WAS NEVER DULL.

WE HAD ONE SECTION IN THE FIELDS FOR COTTON. WE TRIED TO RAISE ENOUGH TO MAKE TWO BALES EACH YEAR. YOU CAN'T APPRECIATE HOW MUCH COTTON IS IN A BALE UNTIL YOU PLANT IT AND WEED IT AND THEN HELP PICK IT. YOU HAVE TO GROW A LOT TO GET A NICE FINISHED BALE. WE MADE BETWEEN TWO AND FOUR HUNDRED DOLLARS A YEAR ON THAT COTTON, DEPENDING ON THE PRICE AT THE COTTON GIN — THE PLACE WHERE THEY BUY RAW COTTON, TAKE OUT THE SEEDS, AND MAKE IT INTO BALES.

COTTON PRICES WERE ALWAYS SET AT AN EXCHANGE IN A BIG CITY LIKE NEW ORLEANS. YOU COULD READ WHAT PRICE YOU SHOULD GET IN THE NEWSPAPER. ONE YEAR, WHEN WE TOOK OUR COTTON TO THE GIN, THE RATE THE MAN GAVE US WAS LOWER THAN THE RATE IN THE PAPER. IT WASN'T HARD TO FIGURE OUT HOW

28

ballpark. Writers like Langston Hughes and musicians like Duke Ellington did their part. Because a lot of this action took place in Harlem, a black section of New York, people call this time the Harlem Renaissance. Artists like Aaron Douglas, William H. Johnson, and Augusta Savage helped make black art strong.

Aaron Douglas is the artist most closely tied to the Harlem Renaissance. Unlike Henry O. Tanner, Douglas didn't duck from being called a "black artist." He wanted to show how important black people were in building America. He was born in Kansas around the turn of the century and he came to Harlem in the early 1920s. He did a lot of work for books and magazines, and he also painted scenes from around the city. But he's most famous for his murals, in which he showed black daily life and history. He needed to make his figures big so people could see them, even from a long distance. He drew large silhouettes, or shadow designs, of people performing dramatic, heroic actions. He showed them putting up buildings, praying, dancing — acting proud. He used basic shapes so you couldn't misunderstand his art. After the Harlem Renaissance ended, Douglas went to Fisk University in Nashville, Tennessee, where he became head of the art

MUCH WE WERE SUPPOSED TO GET — YOU JUST MULTIPLIED THE RATE BY THE POUNDS OF COTTON. WHEN THE GUY DID HIS MULTIPLYING, IT WAS WAY UNDER WHAT WE WERE SUPPOSED TO GET. I SPOKE RIGHT UP AND TOLD MY FATHER THAT THE PRICE WAS WRONG. FOR THE FIRST TIME IN MY LIFE, MY FATHER TOLD ME TO BE QUIET. HE ORDERED ME TO GO OUT AND SIT IN THE TRUCK. WHEN YOU'RE THIRTEEN, YOU DEAL WITH WHAT'S FAIR. THIS WASN'T FAIR — WE WERE BEING CHEATED. I WENT BACK AND SAT IN THE TRUCK AND WAITED. DRIVING HOME, NEITHER ONE OF US SAID ANYTHING. NOT ONE WORD. WE WERE ALMOST HOME WHEN HE SAID, "YOU NEVER SAY ANYTHING LIKE THAT IN PUBLIC. NEVER, EVER, SAY IT IN PUBLIC." HE WAS TELLING ME THAT RAISING A FUSS WITH WHITE PEOPLE WAS VERY DANGEROUS. I LEARNED SOMETHING THERE. WE DIDN'T HAVE MUCH MONEY, AND WE HAD JUST BEEN CHEATED OUT OF SOMETHING WE'D WORKED HARD TO EARN. I STARTED TO NOT LIKE BEING A FARMER AFTER THAT.

29

◆ ◆ ◆

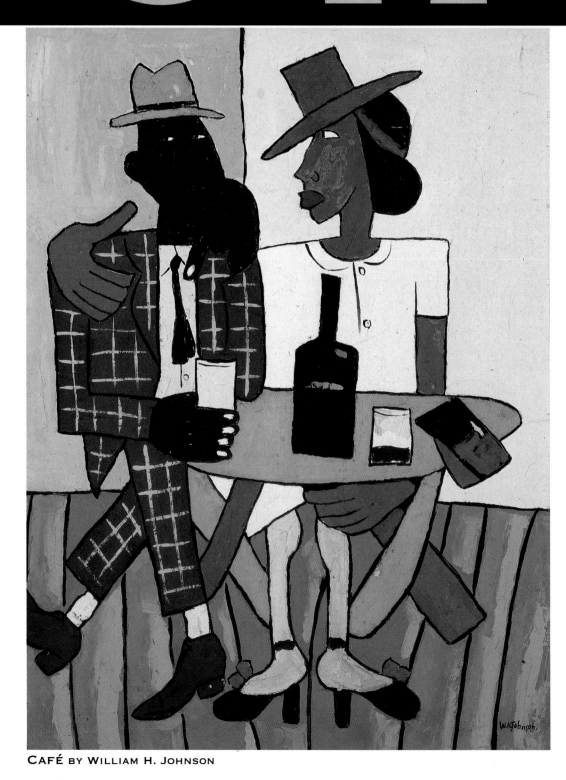

CAFÉ BY WILLIAM H. JOHNSON

department. He lived well into the 1970s, and he kept working all that time. He said that he was always learning something new. He had a restless, hungry mind that kept his work fresh and interesting.

William H. Johnson

came to New York in 1918 determined to become an artist. Born in South Carolina in 1901, Johnson had a plan: work hard to make enough money to attend an art school. For three years, Johnson worked day and night at low-paying jobs. Finally, in 1921, he enrolled at the National Academy of Design. During five years there, Johnson won eight prizes for his art. He so impressed his teachers that they helped him get enough money together to study art in Paris. That was where he met Henry O. Tanner, who was as impressed as Johnson's teachers were by the young artist's work. While studying in Europe, Johnson became an expressionist painter.

Expressionism is a style of painting where the artist tries to show his or her inner feelings. The expressionists often used bright colors and crooked figures in their paintings, trying to get viewers to react with emotion. While in Europe, Johnson met the Danish artist Holcha Krake, who worked with fabrics. After he traveled back to America — where he won more prizes for his art — he went back to Denmark and he and Krake were married. Johnson might well have spent the rest of his life in Europe because he loved it there and felt at home. He felt free of racism and prejudice — he felt accepted by Krake's family and all the people he met. But the rise of Germany's Adolf Hitler and the Nazi Party put an end to Johnson's dreams. The Nazis didn't like Johnson's style of art. They called it immoral. The fact that he was a black man married to a white woman also would have meant trouble for him with the Nazis. He could expect the same sort of trouble in the

31

United States, but in 1938 the couple moved to America, just before the outbreak of World War II in Europe. Aside from some self-portraits, Johnson had never done much work that showed African Americans. When he moved back to the United States, that all changed — along with his style of painting. He was still an expressionist, but his style became more "primitive." Even though he had a lot of training, he tried to make his paintings as simple and flat-looking as possible. It was during this time that he produced his most famous work. Along with religious works, he painted scenes of everyday African American life. It was at just this time, however, that things turned bad for Johnson and Krake. She got cancer and died in 1944. Johnson was never the same after that. He continued to paint, but friends noticed that he was acting strangely. After World War II ended, he moved back to Denmark, but Krake's family sent him back in 1947 because he had become mentally ill and they thought he could be cared for better in this country. For the next

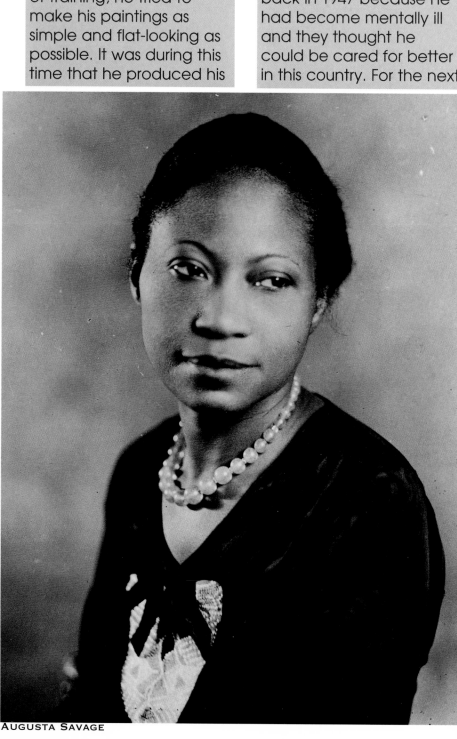

AUGUSTA SAVAGE

AUGUSTA SAVAGE

23 years, Johnson lived in a mental institution. He died in 1970, just as his work was becoming famous again. No one knows how his life and work would have turned out if all these bad things hadn't happened.

Augusta Savage

was a sculptor, like Edmonia Lewis. But Augusta Savage had an even harder time getting her art accepted than Lewis did. She was born in Florida in 1892, the daughter of a minister. Right at an early age, Augusta liked to make clay figures. Her father didn't like that and even beat her when she kept it up. She once said he almost beat the art right out of her. Almost, but not quite. She kept on sculpting and in high school she finally won her father's approval when she made a religious statue that made him cry. She then worked in tourist places making animal statues until she finally took off for New York in the early 1920s. She got paid to make busts, or heads, of W.E.B. Du Bois, the great black leader, and another leader of the time, Marcus Garvey. One day she read about a competition to pick 100 young women to study art in France for a year. She entered. Any expenses not covered by the money from the competition would have been covered by some friends in Harlem. Well, she wasn't picked, and she felt that she wasn't picked because she was black. She was right — the people judging the competition admitted it. That brought out her fighting spirit, and she caused a big fuss in the New York art world. The experience changed her life. From then on, she fought for black artists to be judged on their talent, not their color. She eventually did get to France after she sculpted a bust of a young boy. She called the

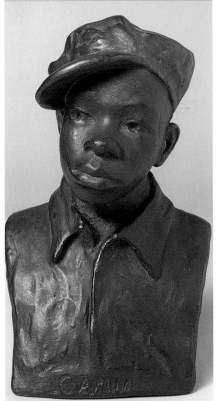

GAMIN BY AUGUSTA SAVAGE

bust *Gamin*, which means a young person who lives on the street. That sculpture was so well-liked, she won money to study in Paris. Some of her expenses were paid by the nickels and dimes given her by the people of Harlem, who had come to know and love her art.

When she came back, the Great Depression had started in America. That was a time when nobody had money. Black people were hit the hardest, but the whole country suffered. Augusta Savage started an art studio, the Savage Studio of Arts and Crafts. She taught the children of Harlem about art. The government started a program called the WPA, which put a lot of artists to work. Writers, painters, playwrights, poets, they all got work through the WPA. Augusta Savage kept on teaching with the WPA's help. She changed the name of her school to the Harlem Community Arts Center, and she began teaching adults. Because teaching took so much of her time, she did less of her own art. Augusta Savage thought art should be open to everyone — black or white, rich or poor. She said, "If I can inspire one of these youngsters to develop the talent I know they possess, then my monument will be their work. No one could ask for more than that."

Her story has a sad end. Augusta Savage was poor all her life. And she fought many battles for black artists. There came a time when it all became too much. She moved out of Harlem, and for the rest of her life, she kept herself apart from nearly everyone. When she died in 1962, she was almost forgotten. But her work lives on — the work that wasn't lost or destroyed — and so does the work of some of the artists she helped.

5

ART INSTRUCTION SCHOOL

OTHER THINGS IN MAGNOLIA ALSO PUSHED ME TOWARD BECOMING AN ARTIST. ONE WAS A PICTURE OF A LITTLE DEER IN AN ADVERTISEMENT. WHEN I WAS IN HIGH SCHOOL IN 1964, WE GOT OUR FIRST TELEVISION SET. IT WAS A LITTLE BLACK AND WHITE SET AND IT BROUGHT THE WORLD INTO OUR HOUSE. ONE OF

35

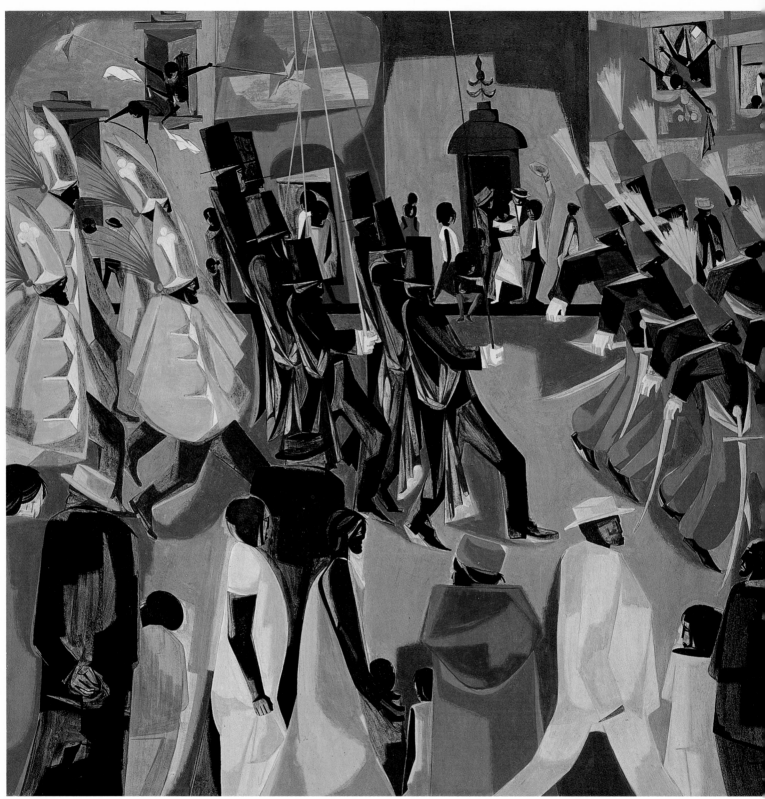

PARADE BY JACOB LAWRENCE

JACOB
LAWREN

Jacob Lawrence,

a great artist, started working during the 1930s. He was born in 1917 in New Jersey but spent his early years in Harlem. The family was poor — his mother worked as a maid and her two sons would do little jobs to help support the family. But Jacob loved art. He got some free training in community centers in Harlem. One of his teachers was a man named Charles Alston and another was Augusta Savage herself. It was during the Great Depression and Lawrence's family was on welfare. He dropped out of high school to look for jobs to help keep the family together. That happened all the time during those days. Through a lot of plain hard work, Savage got him a place on the WPA's Federal Arts Project. It was his job to produce two paintings every six weeks. He got enough money from this to devote all his time to art. Lawrence said that if Savage hadn't gone to bat for him, his art career would have ended right there.

Lawrence had made a name for himself the year before he got the WPA job. He had learned about a man named Touissant L'Ouverture (too-SAHN LOOV-air-tyoor), a hero in Haiti. Until he was 50, L'Ouverture was a slave. Then he led a revolt in the 1700s against Haiti's French rulers. After he won and helped end slavery in Haiti, he was made president of the country.

THE FIRST THINGS THAT GOT MY ATTENTION WAS AN AD FOR AN ART SCHOOL. IT SHOWED A DEER AND UNDERNEATH THE PICTURE, THE WORDS SAID DRAW ME. SO I DID, AND I SENT IT OFF TO THIS PLACE IN MINNEAPOLIS, MINNESOTA. THEY SENT BACK AN ART TEST. THEY GAVE ME THESE PICTURES AND I HAD TO COPY THEM. IF THEY THOUGHT I WAS GOOD ENOUGH, THEY WOULD PUT ME IN THE SCHOOL.

I SENT THOSE DRAWINGS BACK AND THEY LIKED THEM ENOUGH TO GIVE ME THEIR SALES PITCH. THERE WAS NO WAY WE COULD AFFORD IT, BUT WE HAD ENOUGH TO SIGN UP FOR LESSONS THAT WERE SUPPOSED TO LAST FOR THREE MONTHS. I DID ALL THOSE LESSONS IN TWO OR THREE DAYS. WHERE THEY SAID "DRAW," I DREW. WHERE THEY SAID "DO THIS," I DID THAT. I SENT IT ALL IN AND MY TEACHER WROTE ME BACK AND SAID I HAD TO TAKE MY TIME WITH THESE THINGS, I SHOULDN'T DO THEM ALL IN ONE SITTING. SO I DID THEM AGAIN AND SENT THEM BACK TO MY TEACHER — MY FIRST ART TEACHER.

I HAD THE BEST TIME IN MY LIFE WITH THOSE LESSONS, AND IT WOULD HAVE ENDED THERE BECAUSE WE DIDN'T HAVE MONEY FOR MORE. BUT THAT JULY, A MAN FROM THE SCHOOL CAME DRIVING DOWN OUR LITTLE DIRT ROAD IN A BIG WHITE CAR. HE WAS WHITE HIMSELF. WHEN MY BROTHER FOUND ME AND TOLD ME ABOUT HIM, I CAME RUNNING. THERE HE WAS, SITTING ON OUR PORCH, SWEATING AND DRINKING ICED TEA.

HE OBVIOUSLY DID NOT FIT IN WITH THE REST OF THE PEOPLE THERE. IN MISSISSIPPI AT THAT

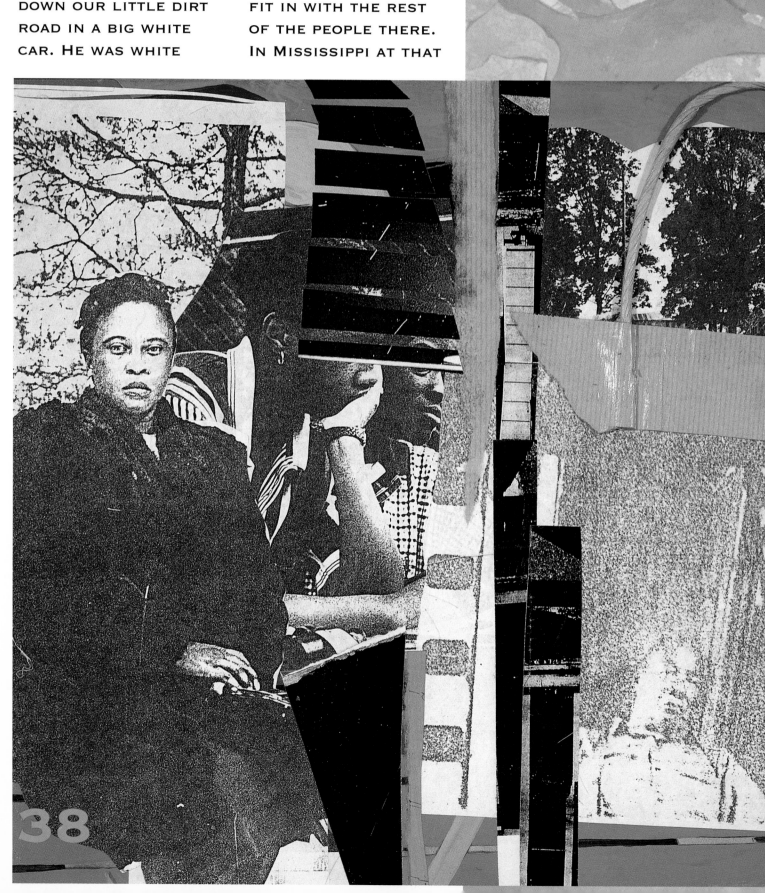

38

TIME, A WHITE PERSON WOULDN'T DARE COME TO YOUR HOUSE AND SIT ON YOUR PORCH. AT CERTAIN TIMES, BLACKS AND WHITES COULD WORK TOGETHER. BUT THERE WERE NO TYPES OF SOCIAL THINGS YOU DID TOGETHER. EVERYTHING WAS COMPLETELY SEPARATED — THIS MAN WAS ONE OF THE FIRST WHITE PEOPLE I EVER TALKED TO. IT WAS A STRANGE THING TO HAVE THIS GUY SITTING ON THE PORCH DRINKING ICED TEA.

HE TOLD US THAT I COULD HAVE A SCHOLARSHIP IF I ENROLLED AT THE SCHOOL IN MINNEAPOLIS. HE WAS OFFERING ME $12,000 A YEAR TO FINISH HIGH SCHOOL, START COLLEGE AT THE UNIVERSITY OF MINNESOTA, AND WORK WITH A STUDIO DRAWING CARTOONS. MY FOLKS SAID WE'D THINK ABOUT IT, AND AS SOON AS HE LEFT, MY MOTHER SAID, "YOU AIN'T GOING NOWHERE! IT'S TOO COLD UP THERE. I DON'T EVEN KNOW IF PEOPLE LIVE UP THERE, IT'S SO COLD!"

OTHER PEOPLE AROUND TOWN AND IN HIGH SCHOOL SAID I SHOULDN'T DO IT, EITHER. THEY SAID I NEEDED MORE OF AN

But later he was captured by his enemies and taken to France, where he died in prison. Lawrence knew he couldn't make just one painting about a man who had led such a long, adventurous, and tragic life. So he decided to make many paintings — 41 in all. Each painting captured a different event in L'Ouverture's life. Each picture was fairly small, and Lawrence had them all planned out before he started to actually paint. He lightly penciled the outlines for each painting and he knew what colors he was going to use before he started. He hung these rough drawings up around a room and then began to paint. If he needed a certain kind of blue in drawings 1, 7, 12, 19, 32 and 41, he'd do that blue all at once. This technique, or way of painting, really makes the whole series look like one story.

Lawrence painted many other series. Probably his most famous is *Migration of the Negro to the North*. This was the Great Migration, which began around the year 1910 and lasted until after World War II. In 60 paintings, Lawrence showed why more than a million African Americans moved from the South to the North — to places like Harlem, Chicago, and Los Angeles. They moved to get away from the bad life they had in the South, where they suffered under Jim Crow laws. Those laws

were put in after the Civil War to keep black people down. This series showed *why* blacks moved north. They wanted to escape things like lynching, which was the torture and hanging of black people by organized gangs of whites. With the migration series, Lawrence showed he was both an artist and a storyteller.

Lawrence didn't only paint series. He made many single works of art about ordinary life in Harlem, street scenes and such. He also painted his experiences in World War II, where he served in the Coast Guard. Then after the war, he broke down and went into a mental hospital for a while. The breakdown happened because he was under a lot of pressure. Over ten years, he had become one of the most famous black artists in the United States. And that was the trouble — the words *black artist*. Lawrence felt those words meant there was a double standard — one for black artists and another for white. He thought when people said *black artists*, they didn't mean *real artists*. Black artists were just playing around in the pasture. Lawrence also knew that there were plenty of other African American artists around who were great artists, and he felt it was unfair — to them and him — to be singled out as *the* "black artist."

39

EDUCATION. WELL, TO THIS DAY, I THINK NOT TAKING THAT OFFER WAS ONE OF THE BIGGEST MISTAKES I EVER MADE. I WENT THROUGH COLLEGE AND I CAME BACK TO TAKE A TEACHING JOB AND FOUND OUT THAT TEACHERS WERE ONLY MAKING $4,000. THIS GUY WAS OFFERING ME THREE TIMES WHAT THEY WERE MAKING. THERE WAS A JOB, THERE WAS AN EDUCATION — ALL MY EDUCATION WOULD HAVE BEEN FREE.

BUT EVEN WITH THAT DISAPPOINTMENT, I KNOW I HAD AN EASIER TIME BECOMING AN ARTIST THAN PEOPLE LIKE JACOB LAWRENCE, HORACE PIPPIN, AND ELIZABETH CATLETT, SOME OF THE MOST IMPORTANT ARTISTS — BLACK OR WHITE — THIS COUNTRY HAS PRODUCED.

After he recovered, Lawrence kept on painting. In 1968, he painted 30 pieces of art for a children's book called *Harriet and the Promised Land.* It was a book about Harriet Tubman, an escaped slave who helped hundreds of other slaves make their way to Canada on the Underground Railroad. He and his wife, the artist Gwendolyn Knight, eventually moved to Seattle, Washington, where they both taught for a long time.

Horace Pippin

might be the most unusual artist we'll meet in this book. He was born in 1888 in West Chester, Pennsylvania, near Philadelphia. At an early age, he and his mother moved to Goshen, a small town in upstate New York. The little schooling Pippin had introduced him to art, which took over his life after he discovered it. When he wasn't working, Pippin drew, or carved, or made things. His life turned around, and almost ended, when America entered World War I in 1917. Pippin became a corporal in the famous all-black 369th regiment. This outfit was handed over to the French Army by the United States Army, and the men in this unit served so heroically the French gave the whole regiment their army's biggest medal. But during his time fighting, Pippin was seriously wounded. He was shot through the right arm and shoulder — the arm he

drew with — and left for dead. Someone found him the next day and brought him in for treatment. After a long, painful recovery, he returned home. His right arm was useless, and for a long time, Pippin didn't know what to do with himself. But his strong love of creating art could not be denied. One day he discovered that, with a lot of effort and time, he could burn images into wood. He would heat a poker in a kitchen stove. When the poker got red hot, he'd take it out of the stove with his left hand. Then he'd switch the poker to his right hand and, supporting his right arm on his leg, he'd burn a line into the wood. Then he'd have to put the poker back into the stove to heat it up again. He used this long, painful process to make small wooden pictures — all of Pippin's work is small, by the way; he just could not manage large panels of wood. After he completed the wood burning, Pippin went back and painted his pictures. To paint, he would guide his right arm and hand with his left. After all that, he would varnish the piece, sometimes giving it more than twenty coats. The varnish acted to preserve the surface from damage and could also add color and even depth to the drawing. As he continued to paint, his right arm got stronger. He no longer had to burn images into wood; he had enough control to paint using an easel. But

he always had to support his right arm and hand with his left when he produced his art.

Pippin's art is beautiful. Many times, he'd recreate scenes from his life in Goshen. Once he did a painting of the abolitionist John Brown on his way to his hanging. He drew that one from a story his grandmother told him when he was a child. A slave herself, she had seen John Brown go to his execution. He also painted scenes from World War I, and he did some religious pictures. Horace Pippin's work is two-dimensional — that means the figures look flat. Each of his works tells a story. Pippin became well-known in the 1930s and began selling some of his works. But he was never that interested in making much money or even in meeting other artists. He realized that he had a limited time on this Earth and so he spent most of it producing his art. He died in 1946, and his work almost died with him. It wasn't until the 1960s that his art was rediscovered and he became popular again.

Elizabeth Catlett was

another important artist who started working at this time. Over her long life, she has done it all — painting, print making, fabric work, sculpture, you name it. She is best known for her metal and wood sculptures, most of which look like the human figure or head. But

HORACE PIPPIN

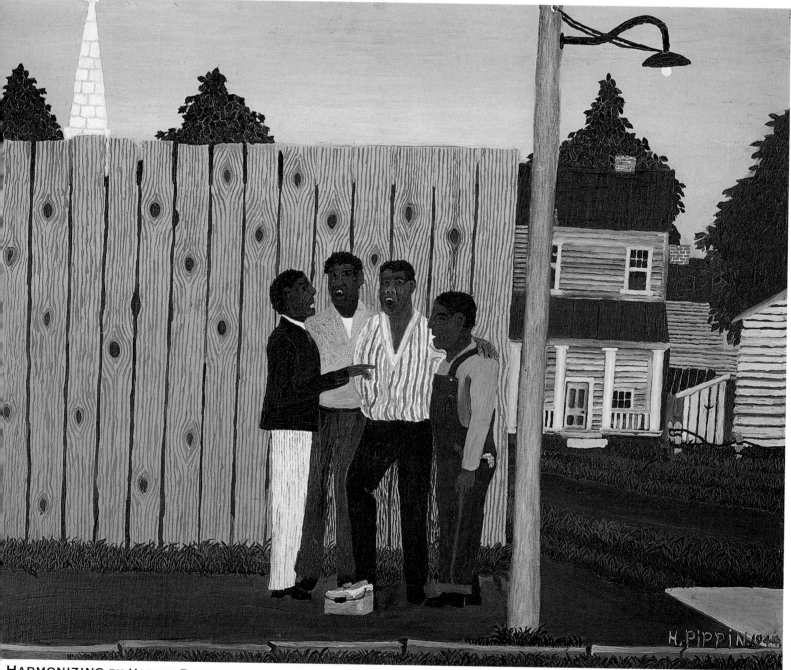

HARMONIZING by Horace Pippin

not just any figure or head — Elizabeth Catlett celebrates people of color in her work, whether they are African, Latin, or Asian. She was one of the first people to call for all-black art exhibitions, or shows. She said these types of exhibitions did not support the separation of blacks and whites. Instead, they made a statement that blacks should have pride in their work and should be able to choose any type of exhibition they might want.

Catlett was born in 1915 in Washington, D.C. In high school, she did well in art and won an important scholarship to study at a school in Pittsburgh, Pennsylvania. But she was rejected by the school

further her art education. There she worked with the famous American painter Grant Wood, who strongly urged her to look to her own people for inspiration. This was the time when she fell in love with sculpting. She liked the feel of shaping clay and wood into figures that seemed to come alive at her touch. She then took a job teaching at the Hampton Institute in Virginia, another all-black school. During World War II, she worked in Harlem, carrying on the teaching tradition of Augusta Savage.

After the war, Catlett felt the United States was not the best place for her to live. She hated segregation and prejudice, so she moved to Mexico. She married a Mexican artist

ELIZABETH CATLETT

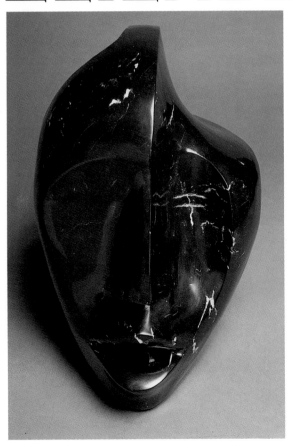

because she was black, and this rejection caused her pain for a long time afterward. It also made her angry. She enrolled at Howard University in 1932 and worked with another great African American artist named Lois Mailou Jones. She graduated from Howard and traveled to North Carolina to become an art teacher at an all-black school. She did not have a happy experience there because she felt the black teachers weren't doing enough to help their students. She also felt all the teachers were underpaid. She soon left and went to the University of Iowa to

and continued her sculpture and printmaking. She also became acquainted with many famous Mexican muralists, whom she admired. She became a Mexican citizen in the 1950s and still lives there today. Some people think Elizabeth Catlett may be the most important African American artist ever because she was one of the first to encourage African Americans to take pride in their heritage and to paint about their people.

SINGING HEAD BY ELIZABETH CATLETT

43

LEAVING MAGNOLIA

BY THE TIME I WAS A SENIOR IN HIGH SCHOOL, THE SOUTH WAS GOING THROUGH SOME BIG CHANGES. BLACK PEOPLE WERE FIGHTING FOR SOME PRETTY SIMPLE RIGHTS THEY DIDN'T HAVE — THINGS LIKE BEING ABLE TO EAT OR GO TO THE BATHROOM IN THE SAME PLACES AS WHITES, AND TO VOTE IN ELECTIONS. PEOPLE FROM THE NORTH WERE COMING DOWN TO HELP IN THE CIVIL RIGHTS FIGHT, TOO. BUT IT WAS MOSTLY UP TO THE PEOPLE WHO LIVED IN THE DEEP SOUTH TO GET THEIR OWN RIGHTS. THE CIVIL RIGHTS MOVEMENT REACHED MAGNOLIA ON THE DAY GRAND MO LU AND THREE OF HER FRIENDS INTEGRATED A RESTAURANT IN MCCOMB, A CITY ABOUT SIX MILES FROM MAGNOLIA. EVERY COUPLE OF WEEKS I WOULD DRIVE GRAND MO LU AND HER THREE FRIENDS OVER THERE. I'D GO HOME AND THEY WOULD SHOP AND EAT AT THE RESTAURANT. THEN I'D PICK THEM UP AT THE END OF THE DAY. WHEN THEY ATE AT THE RESTAURANT, THEY WOULD HAVE TO SIT IN THE "COLORED SECTION." ONE DAY, GRAND MO LU TOLD ME TO WAIT IN THE CAR WHILE SHE AND HER FRIENDS WENT TO THE RESTAURANT. SO I JUST SAT THERE, NOT KNOW- ING WHAT WAS GOING ON. ALL OF A SUDDEN, TWO POLICE CARS ROLLED UP AND THE COPS PILED OUT. I GOT OUT OF THE CAR AND LOOKED IN THE WINDOW. THERE WERE THE FOUR AGING BLACK LADIES SIT- TING AT THE LUNCH COUNTER — A PLACE BLACKS WEREN'T ALLOWED TO SIT. ONE OF THE LADIES, OF COURSE, WAS GRAND MO LU. I COULDN'T HEAR WHAT WAS BEING SAID, BUT I

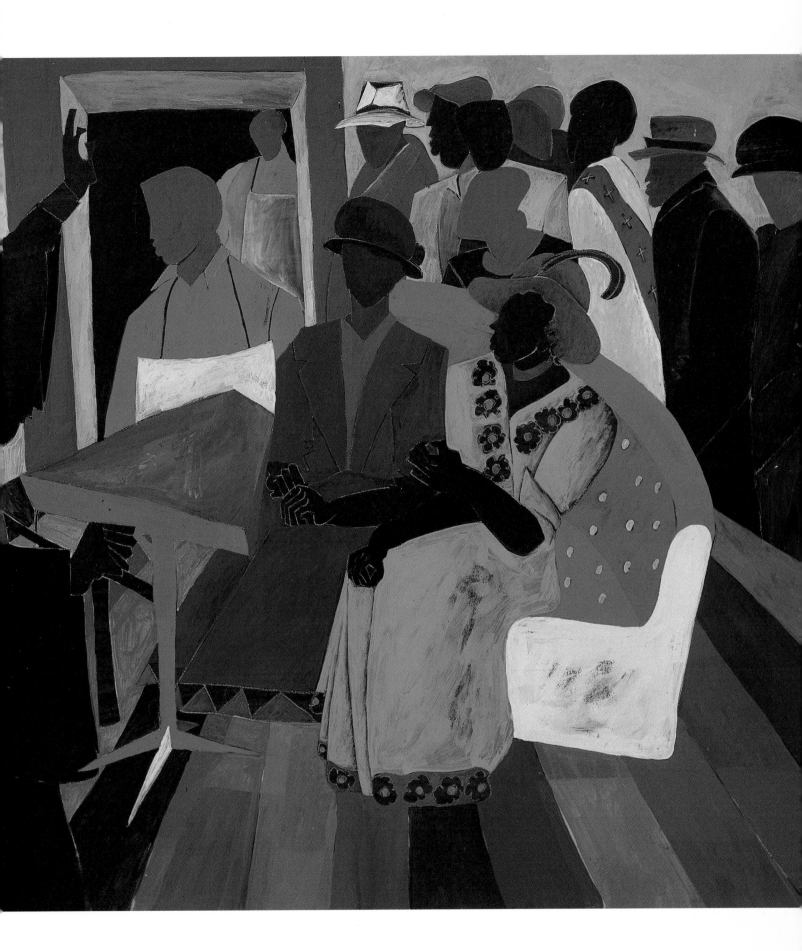

45

COULD SEE GRAND MO LU TALKING TO THE OFFICERS. SHE LOOKED STUBBORN AND THEY LOOKED EMBARRASSED. FINALLY, GRAND MO LU AND HER FRIENDS GOT UP. IN HER USUAL MANNER, GRAND MO LU SLOWLY GATHERED HER THINGS, AND THEN THEY ALL TROOPED OUT. GRAND MO LU SAID THE OFFICERS WERE VERY POLITE. THEY PLEADED WITH THE WOMEN TO LEAVE BEFORE THEY HAD TO ARREST THEM. THE OFFICERS KNEW MY GRANDMOTHER AND HER FRIENDS. BECAUSE THEY WERE ELDERLY, AND BECAUSE THEY WERE WOMEN, THEY COMMANDED RESPECT — EVEN IF THEY WERE BLACK. THE OFFICERS DID NOT WANT TO HAUL FOUR ELDERLY BLACK LADIES OFF TO JAIL.

IT WOULD BE NICE TO SAY THAT GRAND MO LU AND HER FRIENDS CHANGED McCOMB AND MAGNOLIA THAT DAY. THEY DID NOT. AFTER THREE CIVIL RIGHTS WORKERS — TWO WHITE, ONE BLACK — WERE KILLED IN MISSISSIPPI, TENSIONS WERE VERY HIGH. I REMEMBER OUR FAMILY SLEEPING NEAR THE WINDOWS IN BACK OF THE HOUSE SO IF

NIGHT RIDERS CAME, WE WOULDN'T BE TRAPPED. NIGHT RIDERS WERE WHITE MEN WHO TERRORIZED BLACK PEOPLE BY COMING AROUND AT NIGHT AND BEATING THEM UP AND SOMETIMES SETTING FIRE TO THEIR HOUSES. EVEN WITH THIS THREAT, I DIDN'T REALIZE UNTIL MUCH LATER HOW BRAVE GRAND MO LU AND HER FRIENDS WERE. THEY WERE A FEW OF THE MANY PEOPLE WHO, OVER A LONG STRETCH OF TIME, FORCED THE SOUTH TO CHANGE.

I GRADUATED FROM HIGH SCHOOL WITH FIVE OTHER KIDS FROM MY CHURCH, SO IT WAS A PROUD DAY FOR THE WHOLE CONGREGATION. THE CHURCH HELD A CEREMONY AND THE REVEREND HARVEY ALLEN GAVE US BIBLES INSCRIBED WITH OUR NAMES. AT THE CEREMONY, REVEREND ALLEN TALKED ABOUT LIFE ISSUES, ISSUES THAT WERE FACING US AS THE YOUTH OF THE CHURCH. HE URGED US TO CONTINUE OUR EDUCATION. REVEREND ALLEN WAS ONE OF MY HEROES, AND WHEN HE GAVE US OUR BIBLES, HE MADE ME WANT TO GET AS FAR AS I COULD. THAT MEANT LEAVING

ROMARE BEARDEN

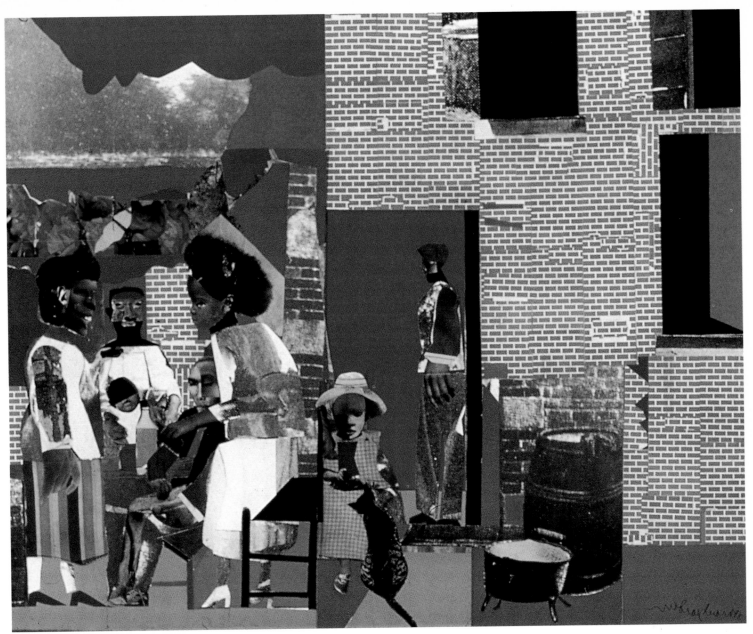

SUNDAY AFTER THE SERMON BY ROMARE BEARDEN

Romare Bearden

was born in 1912 in North Carolina. When he was very young, his family moved to New York, where he met many important people from the Harlem Renaissance. Romare Bearden didn't start out to be an artist. When he graduated from New York University in 1935, it was with a degree in math. But Bearden had worked as a cartoonist for the university's humor magazine and he had done editorial cartoons for some African American newspapers. He quickly decided to become a professional artist and began taking classes. He painted for many years and was always looking for different ways to express himself through his art. In the meantime, he became a social worker, helping people in New York. Bearden became famous as an artist in the 1960s. He's known best today for his collages, which are cut-up pieces of photos or art arranged in a design. His collages show the lives of African Americans. He would use photography to

MAGNOLIA AND GOING ON TO SCHOOL.

ONE DAY, MY HIGH SCHOOL MUSIC TEACHER TOOK MY SISTER CARRIE AND ME TO JACKSON STATE COLLEGE IN JACKSON, MISSISSIPPI. SHE THOUGHT WE BOTH WERE TALENTED ENOUGH TO GET MUSIC SCHOLARSHIPS TO THE SCHOOL. SCHOLARSHIPS WOULDN'T PAY FOR OUR LIVING COSTS, BUT THEY WOULD PAY FOR ALL OUR SCHOOL COSTS. WE WOULDN'T BE ABLE TO GO ON TO SCHOOL WITHOUT THEM. THE MUSIC TEACHER TOLD ME TO BRING SOME OF MY PAINTINGS ALONG. SHE FIGURED THAT IF I DIDN'T GET A MUSIC SCHOLARSHIP, I MIGHT BE ABLE TO GET ONE

FOR ART. AT JACKSON STATE, I GOT THE CHANCE TO SHOW MY ARTWORK TO LAWRENCE JONES, THE HEAD OF THE ART DEPARTMENT THERE. HE LOOKED OVER THE FOUR PIECES I BROUGHT AND THEN LEFT THE ROOM. WHEN HE CAME BACK, HE HAD A PIECE OF PAPER HE ASKED ME TO SIGN. IT WAS A SCHOLARSHIP THAT ALSO GAVE ME A JOB TO PAY FOR MY LIVING EXPENSES. CARRIE GOT A MUSIC SCHOLARSHIP.

I KNEW ABOUT LAWRENCE JONES FROM THE ART TEACHER MY HIGH SCHOOL FINALLY GOT WHEN I WAS A SENIOR. THAT TEACHER'S NAME WAS MORRIS ANDERSON.

UNFORTUNATELY, MY SCHEDULE WAS SO FULL I COULDN'T TAKE HIS CLASS. WE WERE MORE LIKE FRIENDS BECAUSE HE WAS ONLY SIX YEARS OLDER THAN ME. LAWRENCE JONES HAD BEEN ANDERSON'S TEACHER AT JACKSON STATE, AND HIS ART STYLE FOLLOWED LAWRENCE JONES'S STYLE. WAS MORRIS COPYING LAWRENCE JONES? NO, HE WAS USING WHAT A TEACHER HAD GIVEN HIM AND WORKING TO FIND HIS OWN STYLE, HIS OWN WAY OF MAKING ART. THAT HAPPENS ALL THE TIME. IT HAPPENED TO ME. I'VE GONE THROUGH MANY DIFFERENT STYLES AND ONLY NOW DO I FEEL LIKE I'M COMING CLOSE TO MY OWN.

48

BEING AT JACKSON STATE REALLY OPENED MY EYES TO ART — AND TO LIFE OUTSIDE A SMALL FARM TOWN. LAWRENCE JONES BROUGHT ARTISTS LIKE ELIZABETH CATLETT AND JOHN WILSON TO TALK TO US ABOUT WHAT THEY WERE DOING. HE SHOWED US THE WORK OF SOME ARTISTS WHO WERE JUST BECOMING FAMOUS AT THE TIME. THESE ARTISTS WERE OLDER THAN ME, BUT THEIR WORK WAS NEW AND EXCITING — SOMETHING I'D NEVER SEEN BEFORE. TWO OF THEM WERE ROMARE BEARDEN AND FAITH RINGGOLD. FAITH RINGGOLD WORKED WITH QUILTS. THAT BROUGHT BACK MEMORIES TO ME OF GRAND MO LU AND THE WOMEN OF MY FAMILY GETTING TOGETHER TO MAKE QUILTS. I WAS A CHILD AND THE ONLY MALE PRESENT DURING THESE QUILTING BEES. THE QUILT WOULD BE STRETCHED ON A WOODEN FRAME, HANGING IN THE AIR. I'D LAY UNDER THE QUILTS AND MAKE NEW PATTERNS OUT OF THE ALREADY CREATED ONES. THERE'S A NATURAL LINK BETWEEN FAITH RINGGOLD'S ART AND MY FAMILY'S ART.

IT OPENED ME UP TO THE IDEA THAT ART WASN'T JUST PAINTING AND SCULPTURE — THERE WERE MANY KINDS OF ART. MR. JONES ALSO TAUGHT US ABOUT THE GREAT CLASSIC GENIUSES OF ART LIKE CÉZANNE AND DELACROIX. ONE THING JACKSON STATE DID NOT TEACH ME ABOUT WAS AFRICAN AMERICAN ARTISTS FROM THE

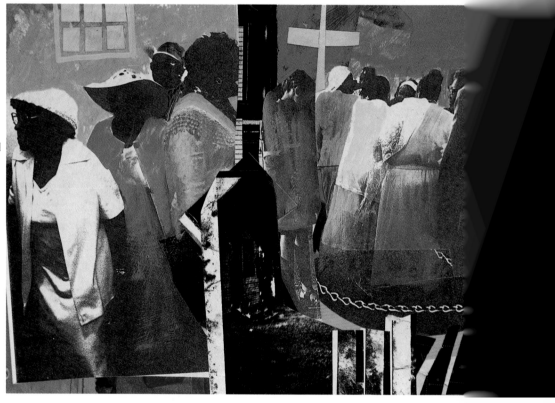

PAST. THERE JUST WASN'T INFORMATION IN BOOKS ABOUT THEM AT THE TIME. LAWRENCE JONES DID HIS BEST TO BRING PEOPLE IN AND TO MAKE US AWARE THAT THERE WERE BLACK PEOPLE WHO ALSO HAPPENED TO BE ARTISTS, BUT MY KNOWLEDGE OF WHAT WAS OUT THERE

WAS INCOMPLETE. I KNEW MORE ABOUT WHITE, CLASSIC ARTISTS THAN ABOUT BLACK ARTISTS.

I WAS GETTING OLD ENOUGH TO LEARN ABOUT THE IMPORTANT SOCIAL, POLITICAL, AND ECONOMIC ISSUES THAT WERE AFFECTING ME. I WAS SIXTEEN WHEN I LEFT HIGH SCHOOL, SO I COULD NOT BE DRAFTED INTO THE VIETNAM WAR. BUT I HAD PLENTY OF FRIENDS WHO WERE DRAFTED OR WHO JOINED THE ARMY RIGHT AFTER HIGH SCHOOL. IT SEEMED LIKE TWO WEEKS AFTER HIGH SCHOOL THEY WOULD GO INTO THE ARMY AND A FEW WEEKS AFTER THAT THEY'D BE IN VIETNAM. AND THEN

IT SEEMED THAT A WEEK OR TWO LATER, WE WOULD BE BURYING THEM AT THE CHURCH. I LEARNED ABOUT VIOLENCE RIGHT THERE AT JACKSON STATE WHEN POLICE AND THE NATIONAL GUARD DROVE TANKS AND ARMORED CARS ON THE CAMPUS WHEN THE STUDENTS HADN'T DONE ANYTHING WRONG. ALL THESE THINGS TOGETHER FORCED NEW IDEAS INTO MY HEAD. I HAD THE NOTION THAT I WOULD BE THE GREATEST ARTIST, BUT FINDING OUT ABOUT OTHER ARTISTS CHANGED THAT A LITTLE BIT FOR ME. FOR ONE THING, I LEARNED THERE WERE PLENTY OF OTHER ARTISTS OUT THERE, AND THEY WERE GOOD. I GREW TO KNOW IT WAS BOASTFUL OR EVEN STUPID OF ME TO THINK I COULD BECOME THE WORLD'S GREATEST ARTIST FROM WHERE I CAME FROM. I LOVED ART, BUT I DIDN'T HAVE MUCH BACKGROUND IN IT AND I DIDN'T HAVE MUCH KNOWLEDGE OF WHAT CAME BEFORE ME. BUT I KEEP LEARNING, AND TODAY I STILL HAVE MANY OF THOSE IMPORTANT DREAMS — I ALWAYS HOPE TO GET SOMETHING SPECIAL OUT OF WHAT I CREATE.

enlarge and reduce parts of his work, cut them up, and put them on a board. He would add painting and design the whole thing so it would make a strong statement. What were these strong statements about? Well, Bearden felt that black artists should understand what was going on around them and show that experience. Bearden felt that artists should address the black experience — their art should be about black culture. He believed the work of African Americans should make it clear that the artist is black and that the art is for blacks. This struck right at the debate between W.E.B. Du Bois and Henry O. Tanner that had taken place many years before. Bearden came down on the side of W.E.B. Du Bois. Romare Bearden died in 1988 after a long career as an artist, social worker, writer, and even a songwriter.

Faith Ringgold was

born in 1935 in New York. Right from the beginning she wanted to be an artist. She graduated from the City College of New York and began teaching art in the New York City public schools. She was a public school teacher for more than 18 years. At the beginning of her career as an artist, Ringgold was an abstract expressionist. Abstract expressionism is a type of art that was popular in the 1940s and 1950s.

Artists who liked this type of painting did not want to make traditional pictures that told a story or looked real. Instead, they were interested in color and the thickness and feel of paint. Many abstract expressionist artists painted very large pictures so the viewer would seem to be wrapped up in them. These paintings were almost meant to be *felt* by a viewer as they were being seen. Ringgold eventually left this kind of art behind because she felt it didn't show her experience as a black woman living in America. She began painting story quilts — art that combines painting, quilted fabric, and storytelling. When an artist uses more than one type of material to make a work of art, the artist is using "mixed media." Some of Ringgold's quilts tell the story of life on a city's streets. Others tell about the struggles and challenges of women. Still others talk about freedom and equality. Ringgold is most interested in the community and the family, and she also wants everybody to understand what she's talking about. That's why her quilts are always colorful. She's also written and illustrated many children's books and she's still working today.

7

UP NORTH

I REALLY BEGAN TO LEARN ABOUT RACISM ONLY AFTER I GRADUATED FROM JACKSON STATE IN 1968 AND GOT A JOB TEACHING ART IN MISSISSIPPI. I'D HAND SOME NOTES I WANTED TYPED TO A SECRETARY AND SHE WOULDN'T EVEN TOUCH THE PAPER. IF I GAVE A WORKSHOP WITH WHITE STUDENTS, THEY DIDN'T WANT TO TAKE DIRECTION FROM ME. THEY COULDN'T BELIEVE THAT SOMEONE LIKE ME COULD TEACH

THEM ANYTHING. THEY COULD ONLY EXPLAIN MY ART TALENT AS AN "UNCANNY GIFT FROM GOD," AN EXPLANATION THAT WOULDN'T MAKE THEM SEEM SMALLER.

SO IN 1970, I DECIDED TO LEAVE THE SOUTH BEHIND. I WAS ACCEPTED INTO GRADUATE SCHOOL AT THE UNIVERSITY OF WISCONSIN IN MADISON. WHEN YOU GO TO GRADUATE SCHOOL, YOU HAVE THE CHANCE TO LEARN MORE ABOUT THINGS YOU'VE ALREADY STUDIED. THAT HAPPENED TO ME, ALL RIGHT — I BURIED MYSELF IN THE HISTORY OF AFRICAN AMERICAN ART. FOR THE FIRST TIME, I BECAME CLOSELY ACQUAINTED WITH OTHER ARTISTS BESIDES HENRY O. TANNER, WHO MY GRANDMOTHER HAD TOLD ME ABOUT, AND ARTISTS WHO WERE STILL WORKING. WITH THAT BACKGROUND, I BEGAN TO FIND OUT WHERE I WANTED TO GO WITH MY OWN ART. AFRICAN AMERICAN ART STUDENTS FROM MADISON, MILWAUKEE AND EVEN SOME FROM CHICAGO FORMED A GROUP CALLED COMMON BOND. IN THAT GROUP, WE DEBATED ART AND POLITICS. AT THAT TIME, AFRICAN AMERICANS

WERE MAKING PROGRESS IN GETTING MORE RIGHTS — BUT THAT PROGRESS WAS COSTLY. MANY PEOPLE WERE BEING THROWN IN JAIL OR EVEN KILLED BECAUSE OF THEIR BELIEFS. THE ARTISTS IN COMMON BOND FELT WE HAD TO DO SOMETHING ABOUT THAT IN OUR ART. WE'D VISIT CHICAGO AND TALK TO YOUNG ARTISTS WHO WERE GETTING A LOT OF ATTENTION, LIKE RICHARD HUNT AND SAM GILLIAM.

STILL, SOME OF THE PEOPLE IN OUR GROUP CHOSE TO DO MORE TRADITIONAL KINDS OF ART. THEY FELT THAT ART MUST STAND ALONE AND IT SHOULDN'T BE USED AS A TOOL TO LIFT UP ANY GROUP. THROUGHOUT THE HISTORY OF AFRICAN AMERICAN ART, YOU CAN FIND BLACK ARTISTS WHO THOUGHT ABOUT ART IN THIS WAY. THEIR ART HAS NOTHING ABOUT IT THAT SAYS "BLACK ART" TO YOU. BUT IN THE 1970S, THE STYLE OF BLACK ART BEGAN TO CHANGE. THERE WAS A CLEAR DECISION TO USE PEOPLE LIKE DR. MARTIN LUTHER KING JR. AND ANGELA DAVIS AS CENTRAL FIGURES IN

ART. THESE PEOPLE WERE FIGHTING FOR THE RIGHTS OF ALL AFRICAN AMERICANS. BUT I HAD A HARD TIME GETTING INTO THINGS. I WAS TRYING TO GET MY WORK LOOKED AT BY ALL PEOPLE, BUT MOST PEOPLE JUST SAW ME AS A BLACK ARTIST. MOST OF THE COMMON BOND PEOPLE COULD ONLY EXHIBIT AT BLACK ART SHOWS — WHICH IS THE WAY MOST AFRICAN AMERICAN ART HAS ALWAYS BEEN SHOWN. OR BLACK ARTISTS WOULD BE FEATURED IN ART PLACES RUN BY

WHITES ONLY DURING FEBRUARY, WHICH IS BLACK HISTORY MONTH. WE DIDN'T THINK THAT WAS GOOD ENOUGH. THAT KIND OF ARTISTIC SEGREGATION WAS ONE REASON MOST AFRICAN AMERICAN ART WAS SEEN AS BEING IN THE PASTURE, AND NOT IN THE STADIUM.

I HAD TO FIGURE OUT WHAT I WANTED TO DO. THE LIVES OF BLACK AMERICANS WERE VERY DIFFERENT FROM WHITES', AND I WANTED TO SHOW THAT CONTRAST. I ALSO WANTED TO SHOW

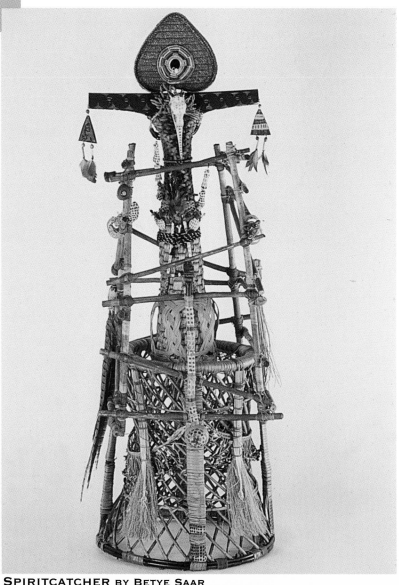

SPIRITCATCHER BY BETYE SAAR

DAVID HAMMONS

WHAT HAD HAPPENED TO ME. I WANTED TO SHOW THE LIFE OF BLACK AMERICANS AND I WANTED WHITE PEOPLE TO SEE IT AND UNDERSTAND IT. I WANTED TO CHALLENGE THE ART WORLD. DURING THIS TIME, BLACK ARTISTS WERE UNHAPPY WITH BUSINESS AS USUAL. ARTISTS LIKE DAVID HAMMONS SHOWED THAT YOU COULD MAKE ART THAT SPOKE TO ALL PEOPLE AND STILL BE A BLACK ARTIST. ARTISTS LIKE BETYE AND ALISON SAAR COULD TAKE EVERYDAY OBJECTS AND

David Hammons

was born in 1943 in Springfield, Illinois, although he's spent much of his life in California and New York City. He burst on the art scene in the late 1960s with body prints — pieces of art in which the imprint of a body is put on a canvas. These body prints are very hard to make. Hammons had to cover himself with something like Vaseline and be lowered carefully onto a paper or board. Then he had to be lifted off without smearing the surface of the print. When that was done, he would sprinkle dried paint pigment over different

areas of the work. He would also paint on the work and maybe even add other printing techniques. *Injustice Case* is a body print made in 1970. The print is about Bobby Seale, a Black Panther Party member who was put on trial in Chicago after riots during the Democratic Party convention. While he was in court, Seale and seven other men who were on trial — all of whom were white — acted up. But only Seale was bound and gagged in his chair. What made Hammons's body prints so powerful was how he was able to capture what was

55

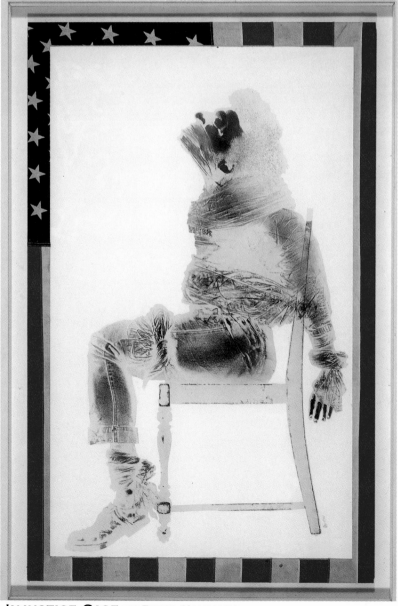

INJUSTICE CASE BY DAVID HAMMONS

MAKE REAL ART OUT OF THEM. I BECAME INTERESTED IN DOING THE SAME TYPES OF THINGS.

MY ART NOW LOOKS AT HOW RACISM HAS AFFECTED ALL PEOPLE IN AMERICA. I AM INFLUENCED BY ARTISTS LIKE LAWRENCE JONES, ROMARE BEARDEN, JACOB LAWRENCE, ELIZABETH CATLETT, FAITH RINGGOLD, AND OTHERS. I AM ALSO INFLUENCED BY "MAINSTREAM" AMERICAN ART. MANY ARTISTS ARE DOING GREAT NEW THINGS NOW. ALL OF THE EVENTS OF OUR TIMES ARE IMPORTANT IN THE UNDERSTANDING OF TRUTH. AS AN ARTIST, MY JOB IS TO FIND NEW WAYS TO SHOW WHAT'S HAPPENING TODAY IN A MEANINGFUL AND INTERESTING WAY.

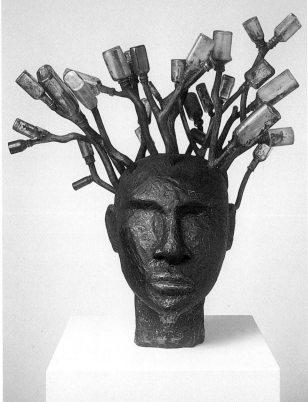

DELTA DOO BY ALISON SAAR

going on at the time. These prints showed that Hammons really understands black culture. Hammons also has made sculptures from "found objects." These are every-day things, sometimes even junk, that everyone sees. In one piece, called *Higher Goals*, Hammons decorated 30-foot poles with bottle caps and topped them with basketball hoops. He says the work is anti-basketball; he says the sport is too important to too many young black males. In this way, Hammons combines art that everyone understands with statements about black life and culture.

Betye Saar and Alison Saar are two parts of a successful artist family. Betye, who was

ALISON

born in 1926, grew up near the mostly black Watts area of Los Angeles. There she saw the Watts Tower, a gigantic construction made of found objects by the folk artist Simon Rodia. A folk artist is an artist who isn't trained in art school but makes art anyway. The Watts Tower is made out of steel rods, broken mirrors, concrete, broken glass and china, bottlecaps, and thousands of other things that people had thrown away. The tower and the way it was made had a big effect on Betye Saar. She makes sculptures that resemble this kind of folk art, although she has had plenty of schooling. In the 1960s, she began showing the racism in society with such pieces as *The Liberation of Aunt Jemima*. It showed the insulting figure of Aunt Jemima, the seller of pancake mix and syrup, holding a butter churn in one hand and a gun in the other. In the past two decades, Betye Saar has used found objects to make other kinds of works. She thinks that people have a need for ritual, or formal ceremonies. Her works are often mysterious but very appealing and interesting. The work called *Spiritcatcher* is almost four feet tall and is made up of many different kinds of objects.

Alison Saar is a sculptor like her mother, but she also paints and does illustrations. Born in 1956, she got to travel in the South when she was in college. She visited a lot of folk artists and was inspired to work in wood, as many of them did. Her big, bold figures are roughly cut and she paints them in such a way that they take on their own lives. Alison is from an artistic family — her mother, father, and two sisters are all artists. She has a richness to draw from. She has worked with her mother in creating art, and like her mother, she does installations with some of her sculptures. Installations are big pieces that can take up the better part of a room. The viewer enters the installation and is supposed to feel a part of it. Both Betye and Alison Saar want their art to connect to people, so their work is often found in unusual places. Alison Saar once did a piece called *Soul Service Station*, in which sculptures of a black man, a gas pump, and a dog were all set up along a highway in New Mexico. The three pieces are decorated with pieces of glass and other ornaments so they really stand out. In the artist's words, the installation was "an invitation for weary travelers, or simply the routine commuter, to stop and think." The piece called *Delta Doo* is made of wood with copper. The hair is made of bottles and other found objects. Like her mother, Alison Saar likes to use everyday objects in her art.

G RAND MO LU DIED IN 1970 WHEN I WAS AT THE UNIVERSITY OF WISCONSIN. IT'S HARD FOR ME TO PUT INTO WORDS WHAT SHE MEANT TO ME. SHE WAS MY INSPIRATION, MY GUIDING LIGHT, IN BECOMING AN ARTIST. SHE SAW THAT I HAD AN INTEREST AND MAYBE A LITTLE ABILITY, AND SHE ENCOURAGED IT. ADULTS HAVE THAT DUTY, TO ENCOURAGE YOUNG PEOPLE WHEN THEY SHOW AN INTEREST IN SOMETHING. THE WHOLE AFRICAN AMERICAN COMMUNITY IN MAGNOLIA TOOK THEIR CUE FROM GRAND MO LU AND ENCOURAGED ME. RIGHT FROM THE BEGINNING IT WAS CLEAR TO ME THAT MY ARTWORK WAS VALUED. THE COMMUNITY PAID ME TO DO MURALS AND OTHER KINDS OF WORK. I WAS ABLE TO HOLD A POSITION IN MY COMMUNITY BASED ON MY ARTWORK, WHICH GAVE ME THE CONFIDENCE TO STEER CLEAR OF THE PITFALLS WAITING FOR YOUNG PEOPLE. I WAS ABLE TO WITHSTAND THE PRESSURE TO TAKE DRUGS OR DRINK BECAUSE I HELD THE POSITION OF "ARTIST." I OWE THAT TO GRAND MO LU.

CHAPTER

WHEN YOU GO THROUGH ART SCHOOL, YOU'RE TOLD TO HIT THE ERASE BUTTON — GET RID OF HOW YOUR FAMILY LIVED, AND HOW YOU GREW UP, AND THE STRUGGLES OF BLACK PEOPLE FOR EQUALITY. YOU ARE SUPPOSED TO DO THIS IF YOU WANT TO STUDY "PURE ART." YOU'RE SUPPOSED TO BE INTERESTED IN COLOR AND FORM AND ALL THE THINGS YOU HAVE TO KNOW IF YOU WANT TO BE AN ARTIST. YOU SORT OF CARVE OUT AN AREA WHERE YOU CAN GROW AND DEVELOP. WELL, I'M STILL TRYING TO HANG

58

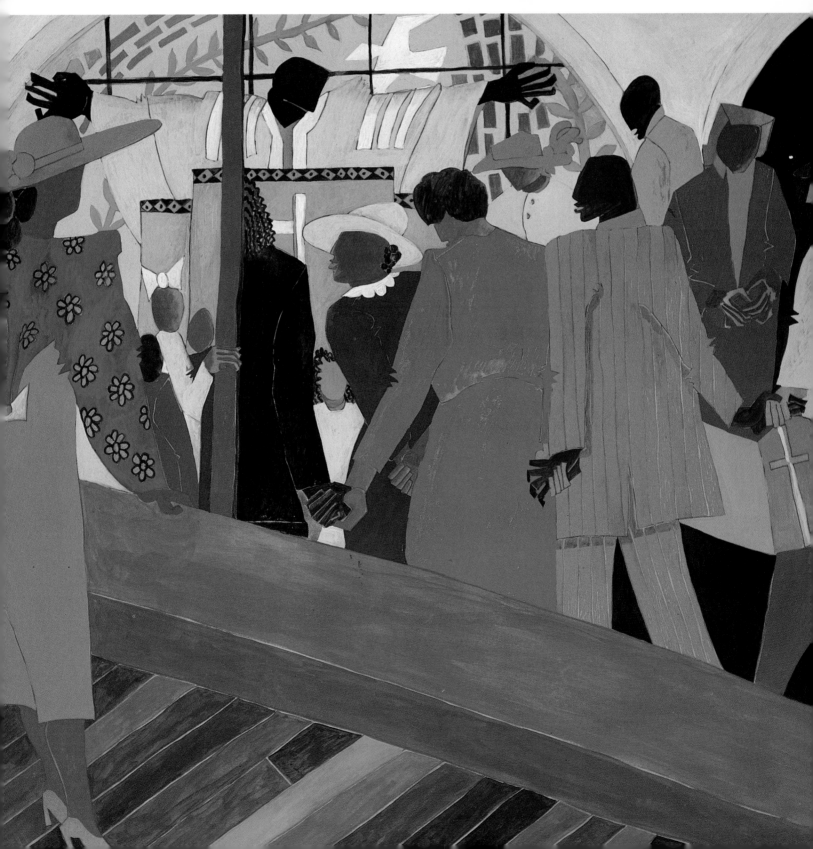

ON TO SOME OF THE OTHER — I DON'T WANT TO ERASE MY BACKGROUND. I DON'T WANT TO FORGET WHERE I CAME FROM AND HOW I GREW UP. IT'S LIKE WHEN YOU'RE CAUGHT WITH YOUR HAND IN THE COOKIE JAR AND YOUR MOTHER TELLS YOU TO TAKE YOUR HAND OUT. YOU STILL TRY TO HANG ON TO SOME OF THOSE COOKIES. I BELIEVE THAT REMEMBERING WHAT CAME BEFORE YOU CAN BRING LIGHT TO WHAT'S HAPPENING TO YOU TODAY. AFRICAN AMERICANS SHOULD OCCUPY AN EQUAL PLACE IN THE MAIN-STREAM OF AMERICAN LIFE. WE SHOULD NOT BE SEPARATE, WE SHOULD BE A DESIGN IN THE NATURAL FABRIC OF SOCIETY. IT IS PART OF MY RESPONSIBILITY TO GRAND MO LU AND THE CHURCH FOLKS OF THE PLEASANT SPRINGS COMMUNITY TO USE MY TALENTS FOR US ALL.

TODAY I THINK MY WORK IS BEGINNING TO TAKE ON SOME INDIVIDUALITY — SOME OF MY OWN STYLE. IN THE PAST, I WORKED A LOT LIKE LAWRENCE JONES, JACOB LAWRENCE, AND ROMARE BEARDEN, BUT I THINK AT SOME POINT THERE WILL BE A FLAVOR IN MY ART THAT IS MOSTLY JERRY BUTLER. WHEN THAT HAPPENS, I'LL HAVE FOUND A PLACE WHERE I THINK MY WORK IS TRULY WORTHWHILE. PEOPLE WILL BE ABLE TO GET SOMETHING FROM IT. THROUGH THE YEARS, I'VE LEARNED MORE ABOUT AFRICAN AMERICAN ARTISTS AND AFRICAN AMERICAN LIFE. NO LONGER DO I SEE BLACK ART AS SECOND RATE ART. I SEE MY ART AS BEING IN THAT PASTURE I TALKED ABOUT EARLIER — BUT IT'S A GLORIOUS PASTURE. THERE ARE NO LIMITS IN THAT PASTURE. IT'S THE PASTURE OF DREAMS.

Other Notable Artists

Charles Alston — Born in North Carolina in 1907, Charles Alston tried to combine the African and American in his art, using shapes from one culture and ideas from the other. He created many murals and paintings that showed the injustices African Americans suffered in daily life. He died in 1977.

Richmond Barthé — A sculptor, Richmond Barthé was born in 1901 in Mississippi. He was the first African American sculptor to have some of his pieces bought by large American museums. His pieces *Blackberry Woman, The Boxer*, and *African Dancer* brought him fame in the 1930s. He died in 1989.

Jean-Michel Basquiat — Born in New York in 1960, Jean-Michel Basquiat was the son of Puerto Rican and Haitian parents. In 1978, he burst upon the art world with graffitti art. Basquiat soon branched out into painting and became famous around the world for his work. He died in 1988.

John Biggers — Born in 1924 in North Carolina, John Biggers is an example of an artist who devoted much of his life to teaching. After working with such artists as Elizabeth Catlett and Charles White, Biggers started the art department at Texas Southern University, an all-black school near Houston. He also did many murals and paintings that showed African American life in Texas.

Beauford Delaney — Beauford Delaney was born in 1901 in Knoxville, Tennessee. He and his younger brother, Joseph, became famous artists in the 1930s. Beauford Delaney spent much of his adult life in France, although he painted street scenes that he remembered from his time in Harlem. Beauford applied brightly-colored paints in layers on his paintings, making them look three-dimensional. He died in 1979.

Joseph Delaney — The younger brother of Beauford Delaney, Joseph Delaney was born in 1904. He is famous for painting crowded street scenes and hundreds of portraits. He is also known for his use of color and for the detailed designs of his paintings. He died in 1991.

William Edmondson — William Edmondson was a self-taught artist who began sculpting in the 1930s when he was over 50. He started out by carving figures for tombstones in Nashville, Tennessee. He carved animals and human figures out of limestone, a soft rock. He used the shape of the stone to give him an idea for the figure he would carve out of it — something that broke the rules of sculpture at the time. He said he began sculpting because God told him to.

Sam Gilliam — Sam Gilliam was born in 1933 in Mississippi. He became famous in the 1960s for abstract canvases and paintings that showed a wide range of brilliant colors. Gilliam's art included draping buildings with brightly-colored cloth and making huge paintings that recall quilts and other types of cloth.

Palmer Hayden — Born in 1890 in Virginia, Palmer Hayden made a name for himself during the Harlem Renaissance. He traveled to Paris during the 1920s, where he studied and made many paintings that showed African American life. During much of his long life, Hayden had to work at other jobs in order to support himself. He became famous in the 1940s and 1950s with his *John Henry* series, which showed the life of the legendary railroad builder. Hayden died in 1977.

Clementine Hunter — Born in 1886 in Lousiana, Clementine Hunter lived to the age of 102. During her long life, most of it spent on a plantation, she

63